Endorsements . . .

Your keen sense of visual narrative unfolds and carries us along, whether we imagine the world in which the cup "lives" or desire to hold it within our hands. Exquisite and beautiful!

Heidi Arbogast, Curator for Visual Literacy, Northwest Museum of Arts and Culture, Spokane, WA

Breathtakingly beautiful, whimsical, nostalgic, heart-warming . . . gorgeous images presented in an artful, extraordinary way. I could hardly wait to turn the next page to see the unique pairing of tea-cup with perfectly-matched enhancements and cleverly-worded narrative. Thank you for giving us such an exquisite gift to share!

Lorene Thompson Berger, Eugene, OR

A total delight for my eyes . . . the wonderful photography highlights the exquisite artistry that has captured my imagination. Not only are the images on "canvas" done with a mastery of composition, but also wonderful color. You have brought a new awareness to my enjoyment of the arts.

Terry Lee, Painter/Sculptor, Coeur d'Alene, ID

This book is a lovely blend of art and storytelling with a dash of intrigue. Nestled in their own unique setting, these delicate objects seem to come alive with personality and charm. This is a book to be savored . . . with a cup of tea, of course.

Michele Davis, Artist, Spokane, WA

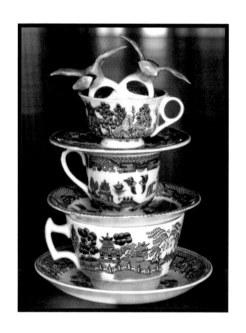

TEACUP ART . . . and Reflections

Joyce Wilkens

TEACUP ART . . . and Reflections
© 2011 Joyce Wilkens

Published by
Deep River Books
Sisters, Oregon
http://www.deepriverbooks.com

ISBN 10: 1-935265-81-4
ISBN 13: 978-1-935265-81-8

Library of Congress Control Number: 2011925264
Printed in the USA

Cover and interior design by Joyce Wilkens

THANK YOU . . .

Keith, for your wisdom, encouragement and support. You are the love of my life and a blessing.

My grown children, for your encouraging words, artistic critiques and computer skills teaching. You rock!

Extended family and friends, for your kind thoughts. Appreciated so much.

Linda, Lorene, Ruth and Willis. Your comments came at just the right time.

To those who generously gifted me teacups. Joyfully accepted and treasured.

To those I met at garage and estate sales, thrift stores and shops. My life is richer because of you.

To my literary group for your friendship and instruction.

To Deep River Books for seeing the value in this book.

To God. You are faithful, and You were the Master Designer of this project.

FOREWORD

Like art, life can be splashed with expected and unexpected curves and colors, offering opportunities to take a good, long look, simmer on your reflections, share your thoughts, and listen to others . . . to learn to respect and appreciate our diversity, especially when blended with the perfect symbol of hospitality, the teacup.

Teacup Art . . . and Reflections is a dazzling display of teacups from around the world that are steeped with stories. Photographed with flair and uniquely showcased, artist and photographer Joyce Wilkens ignites your imagination beyond the porcelain on the page. Each image sparks mystery, wonder, laughter and feelings of peace, and might even make you cry as you reminisce about your own stories . . . where you have been, where you are going, and what inspires you.

Joyce became fascinated with the diversity of teacups after attending a grand tea party. As she soaked in the beauty in the array of cups around the room, she began to wonder what story each cup might hold. Her new fascination became a collection of creative teacups which she has shared with you in this artfully done book. Whether you sip and tell your stories at a table, in a dirt hut or around a mountain campfire, connections are made when you raise a cup.

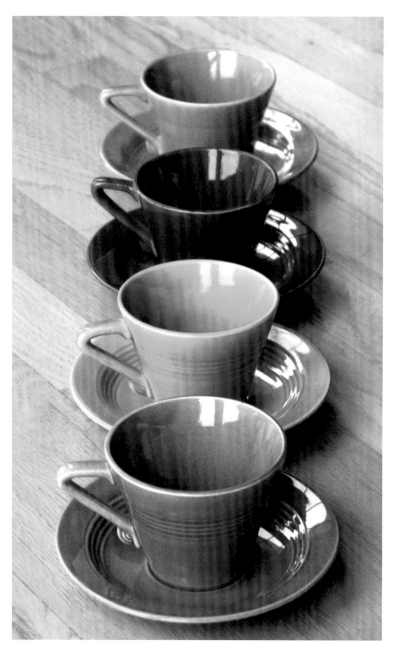

Harlequin Teacups . . . like the blended colors of paints.

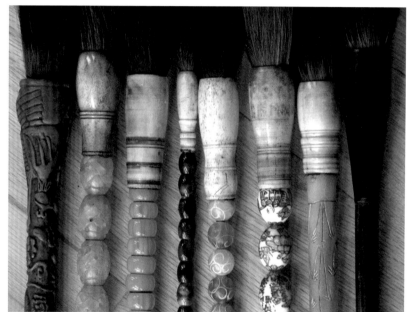

The exotic brushes that help "paint" teacups.

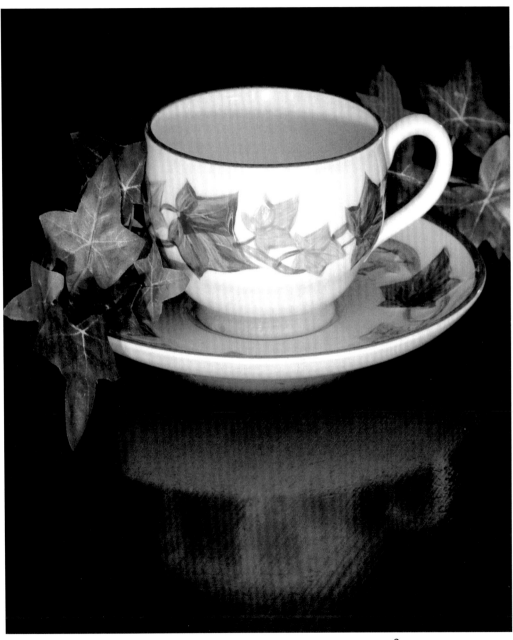

Franciscan Ivy. This antique pattern is a favorite of many. Over the last twenty-five years, I've been collecting just the dinner plates. Only recently did I discover that my paternal grand-ma had these same dishes!

Liberty Blue Teacup . . . depicting Paul Revere's midnight ride. There were two lanterns hung in the Old North Church that night.

"One if by land,
and two if by sea,
and I on the opposite
shore will be . . . "
(Paul Revere)

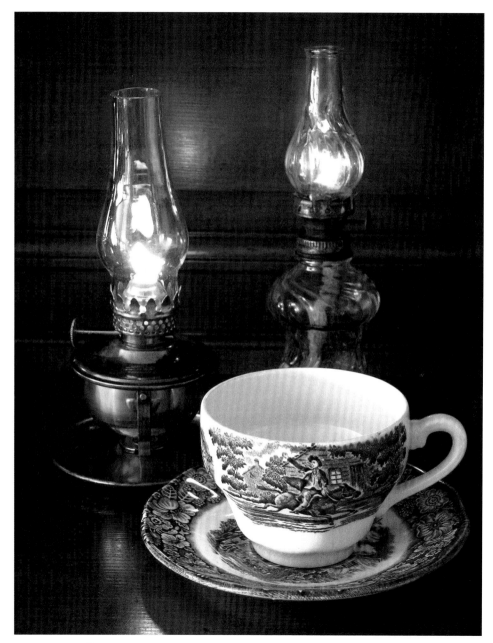

3

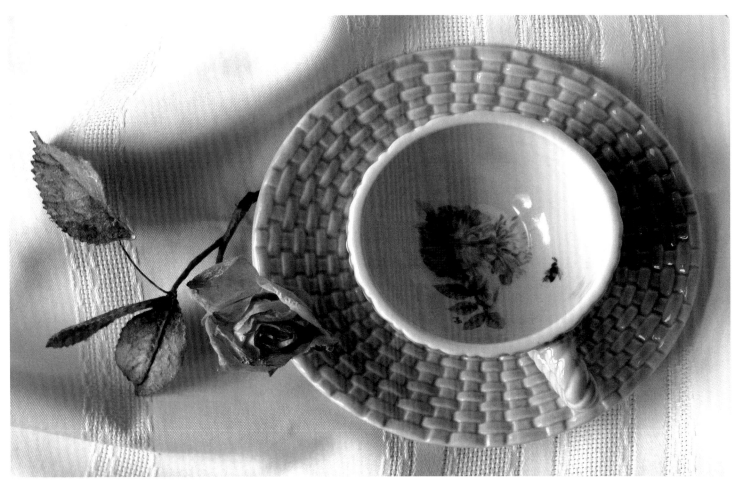

Marjolein Bastin teacup. A honeybee circles in the bottom of this teacup, and a basket-weave look resembles the old-fashioned hives. My husband kept bees in our newly married years. An ominous, humming, dark cloud hovered, funneled and then descended into our plum tree. And so began our adventure with honey, hoods and hurried races to the house!

Austrian teacup

 . . . with glissandos

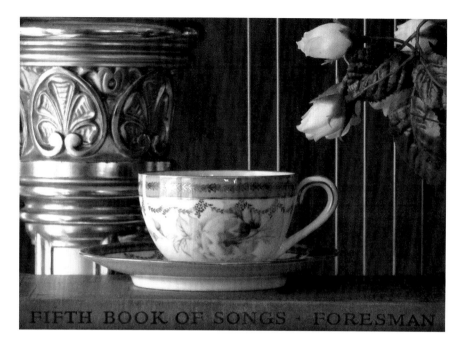

 . . . and muted.

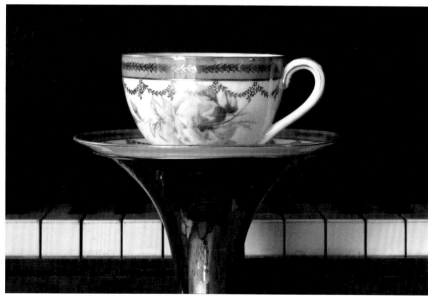

Austrian teacup

. . . with trills

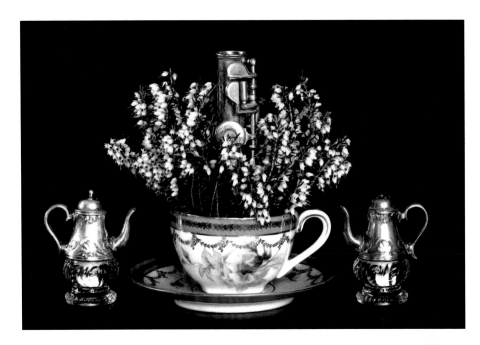

. . . and with practice,

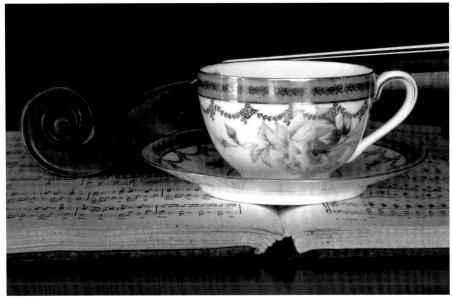

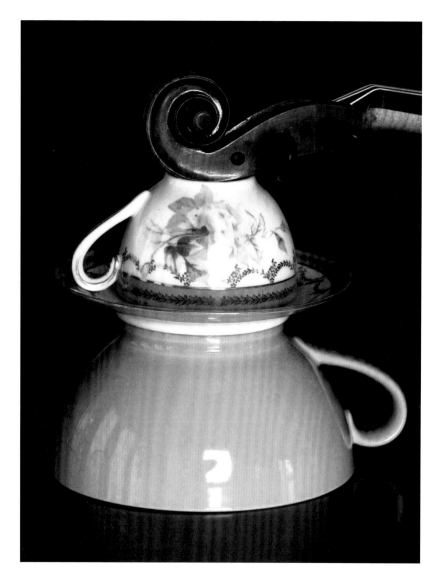

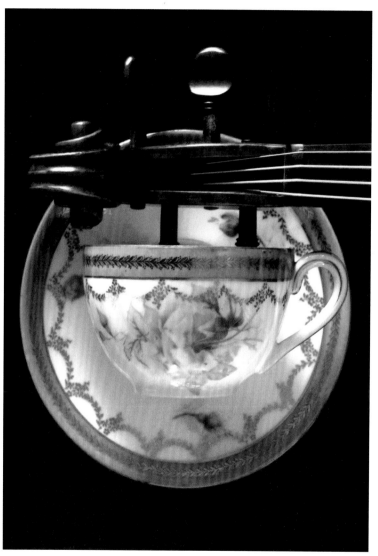

. . . with crescendO . . . and with whOle rest.

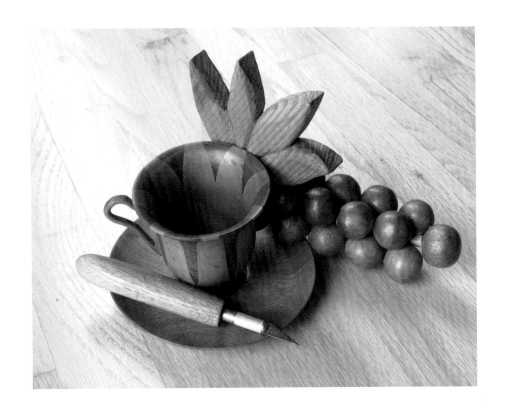

Wooden teacup . . . toasting things hand-crafted. On road trips, I pack my carving knife and often whittle an object out of a branch, driftwood, etc., leaving the carved piece on the ground for a stranger to adopt. Though, maybe the whittled pieces are still waiting to be discovered! I never stuck around to watch.

I've "accidentally" tripped and "spilled" this teacup on unsuspecting visitors. Oh, the drama! Tea and orange slice are plastic. Cup and saucer are permanently glued together. It has seen lots of panic, shock and laughter in its day.

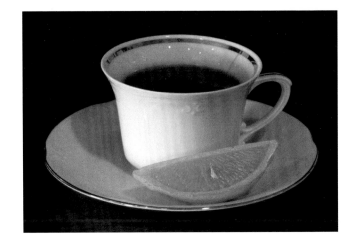

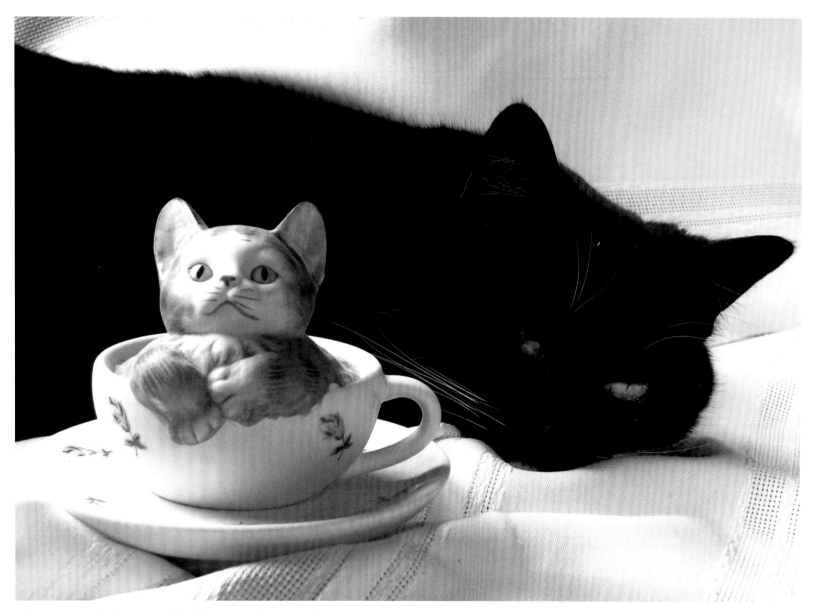

A cup of tea with two mice please . . .

(Musical teacup by Mann)

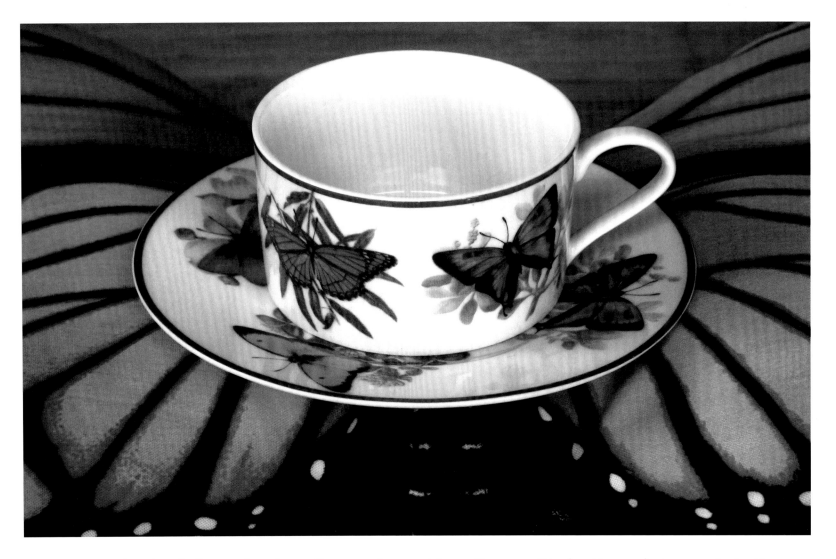

I see my dad wildly swinging the net, making figure 8's in the air to catch these beauties in the Priest Lake mountains of Idaho. After explaining the anatomy of the captured butterfly, he releases it to fade into the forest and freedom.

The word "MOM" is printed on the back of this large cup. When her hat comes off, the hat becomes an ash-tray displaying the word "ASHES."

Mom keeps her hat on for a longer and healthier life. Keeping anything under your hat?

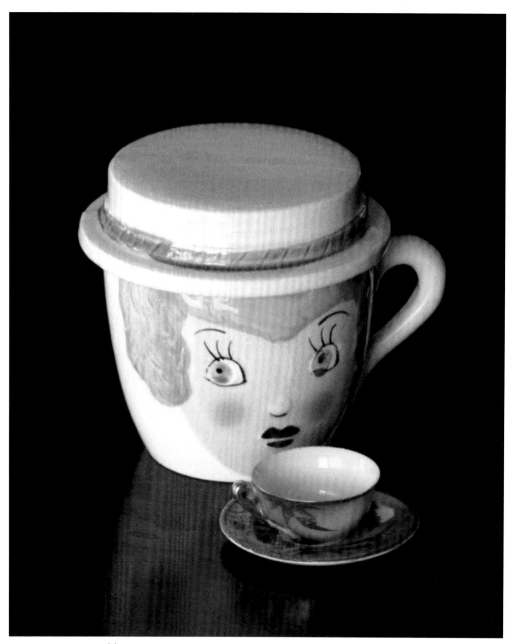

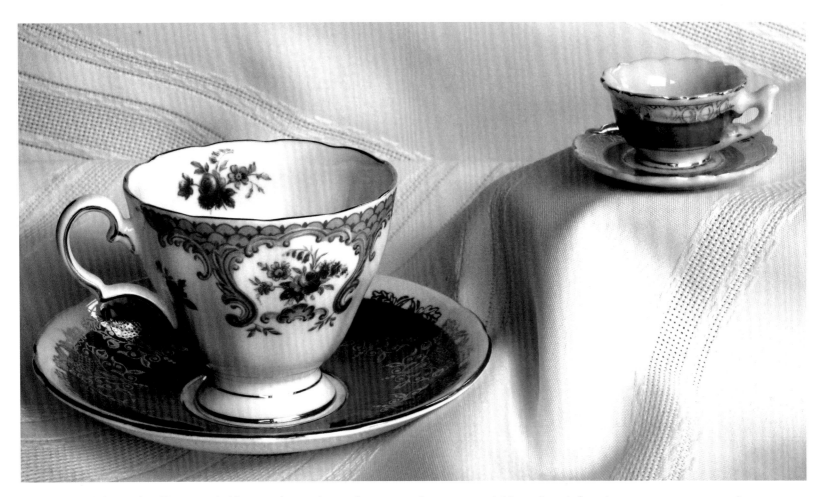

I'm waiting in line at the checkout counter, and I'm behind a woman who has a three-year-old girl in her cart. As the woman moves up to the checkout clerk, her daughter spontaneously yells, "CREDIT!" The clerk grins, and laughter snakes down the line of waiting customers. Little eyes and ears . . . growing up to be just like us!

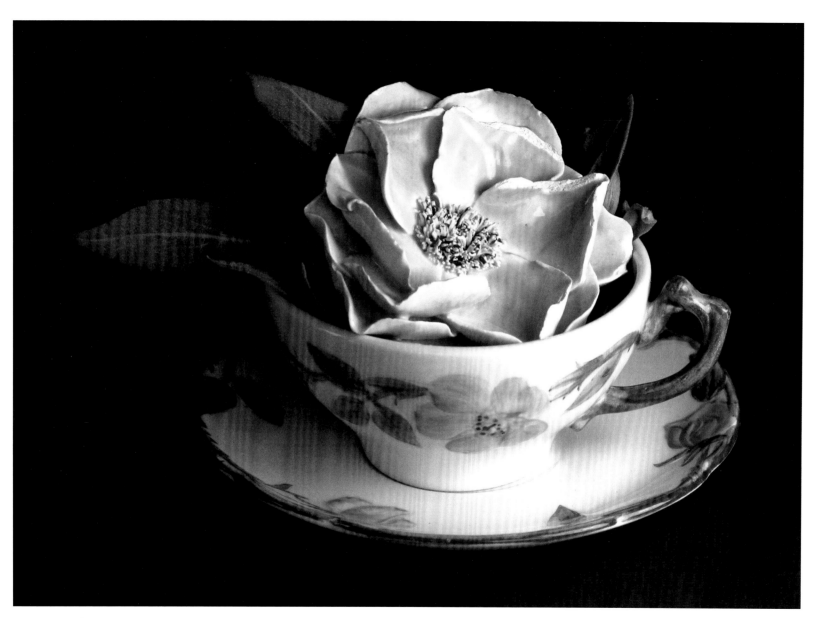

Franciscan Desert Rose.

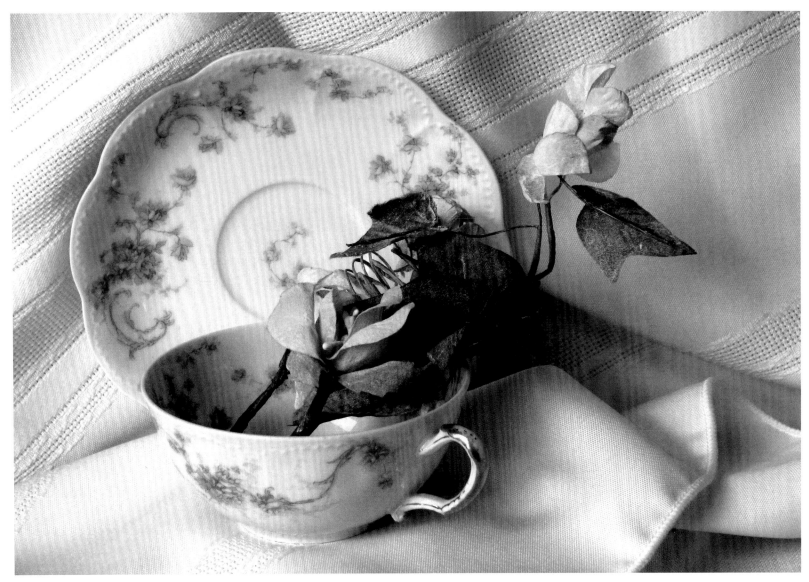

Limoges teacup (France). This cup belonged to my Swedish great-grandma.
I wonder what her hands looked like . . .

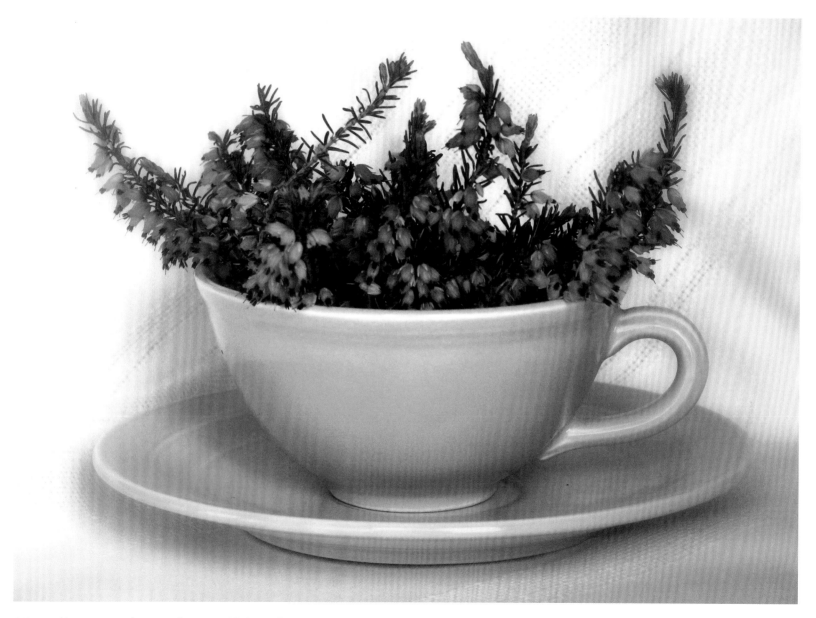

Heather springs from this pink beauty.

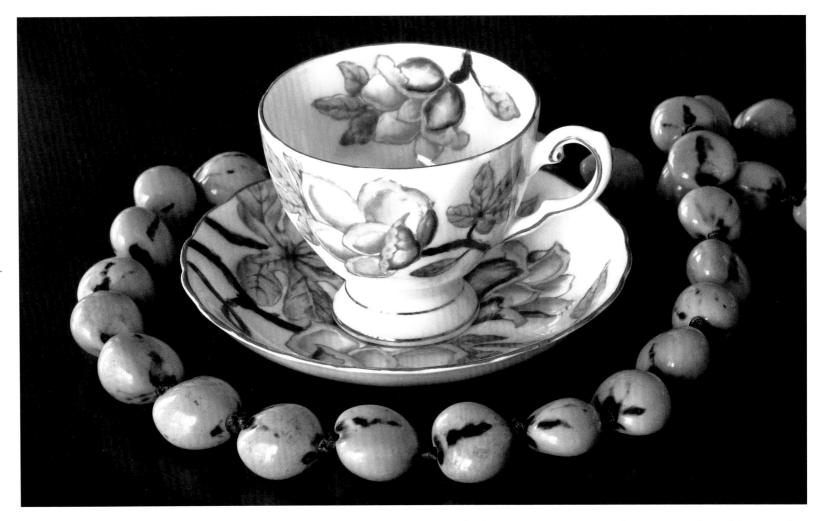

Hawaiian Wood Rose teacup. The Kukui Nut lei was once only worn by Hawaiian royalty since it took much effort to make. The nuts were drilled with holes and then buried for the ants to eat and hollow out the centers. Later, the nuts were dug up and sanded with shark skin to reveal the lighter colored wood.

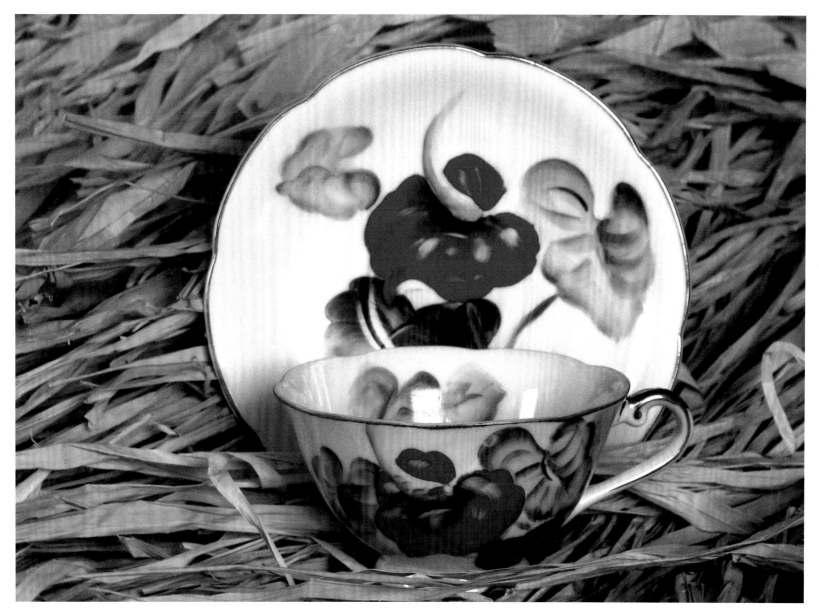

Anthurium teacup . . . in the spirit of aloha.

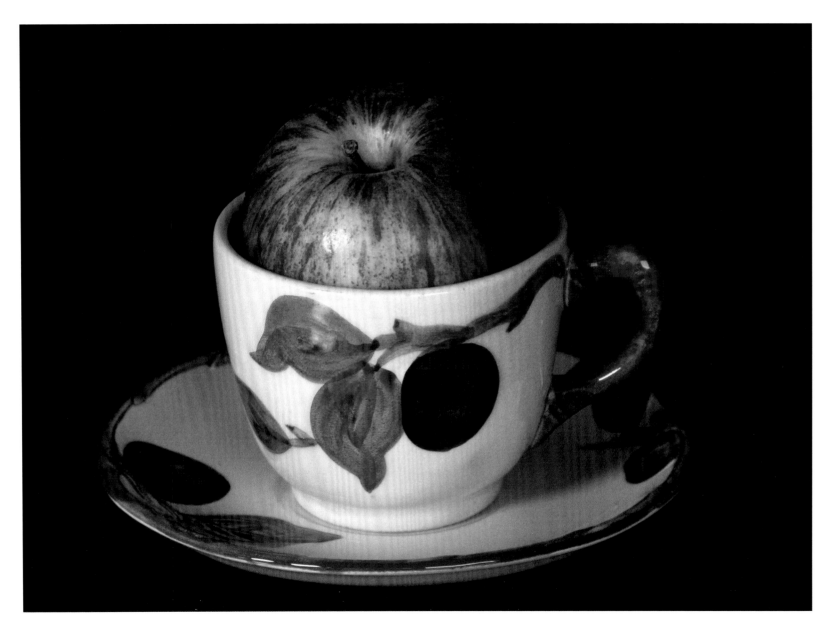

Franciscan Apple teacup.

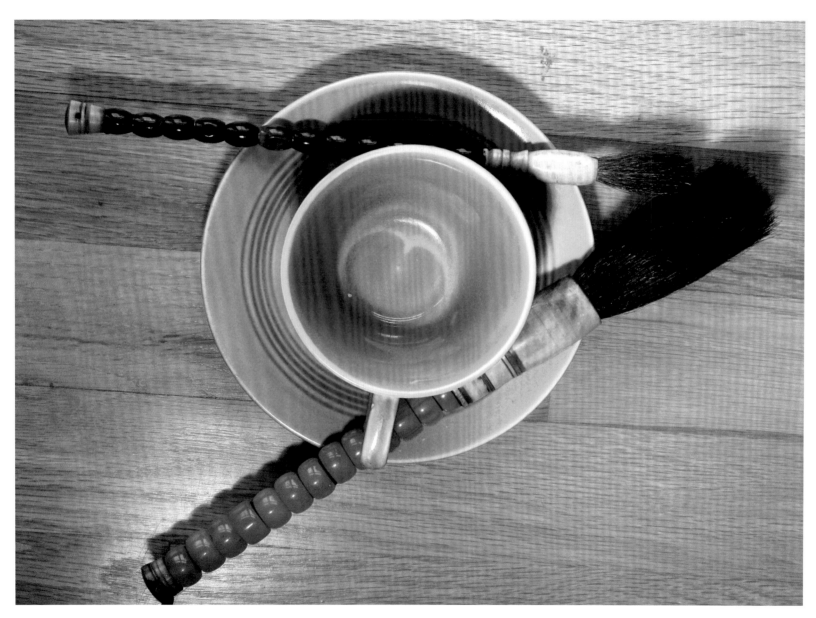

Harlequin teacup . . . with utensils.

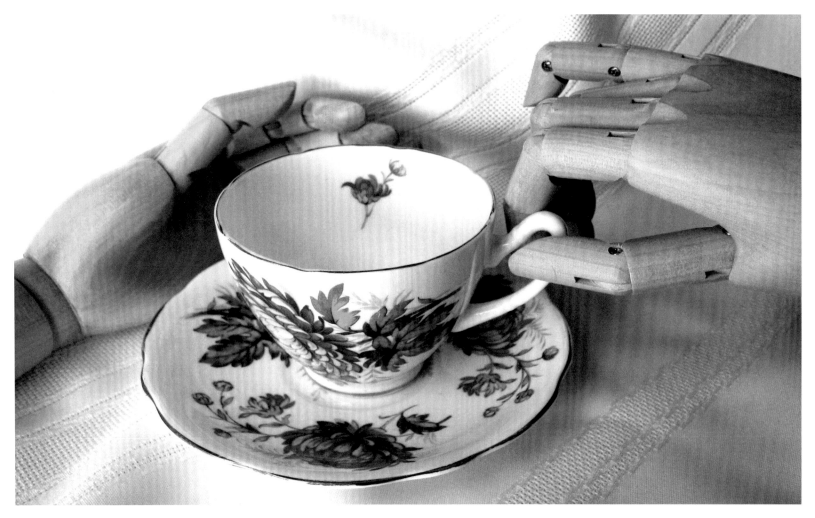

Chrysanthemum teacup. Hands are some of the most difficult things to draw and paint. The old master painters would add up how many arms and legs they would have to paint in order to determine the price of a painting . . . and that's why we say, "That cost me an arm and a leg!"

Sweet Violets. This cup was considered "stolen" and was sold to an antique store for cash. When the "uncomfortable thief" returned the next day with another cup, the store refused to buy. So, this first

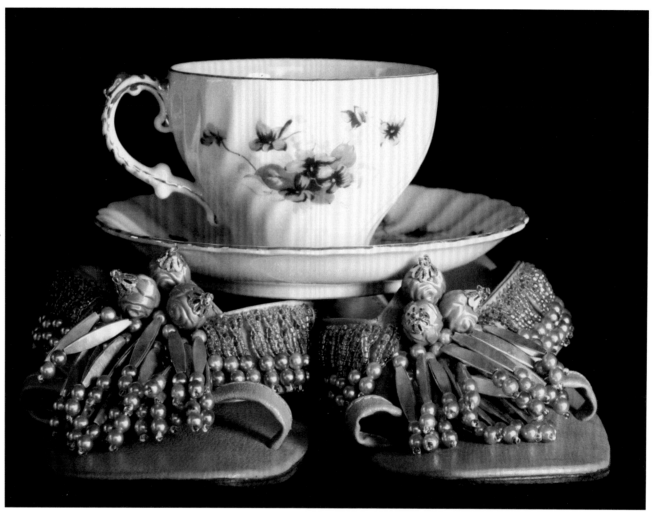

unfortunate teacup, which was whisked away from its rightful family, is now in my "service," and in quite a lovely position, I think. Bad incidences can many times become growth opportunities in the end. Do you have a story?

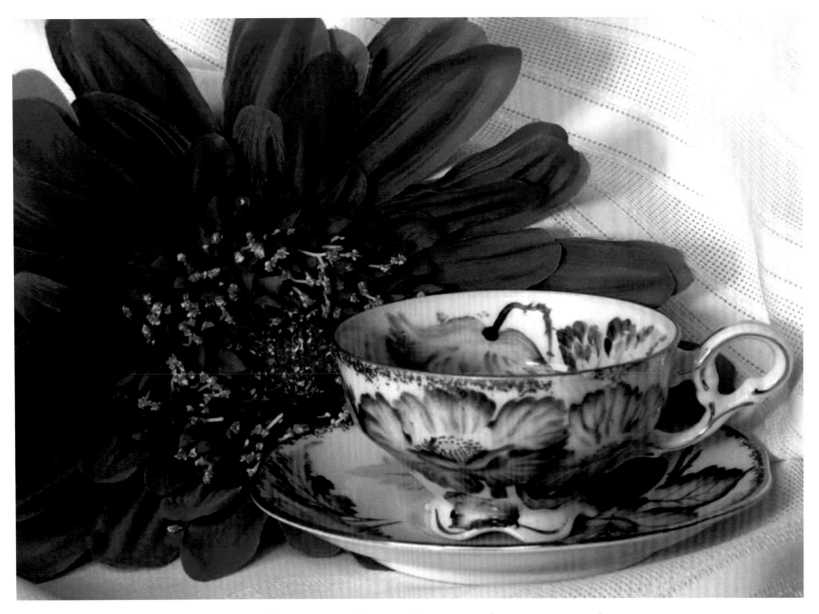

For purple-wearing people . . . and you know who you are!

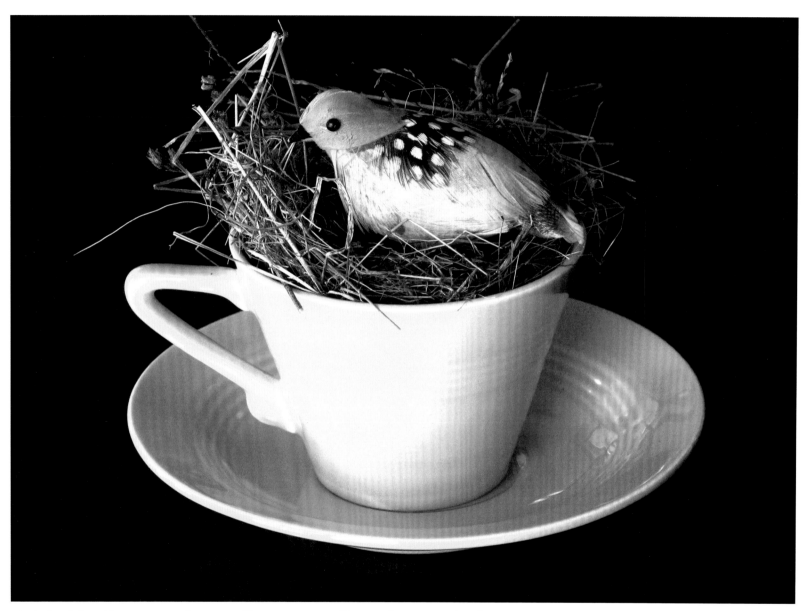

A bird in the cup is worth . . . worthy of a portrait.

and continues to teach language and cooking classes. When I ask her to pose with the Italian teacup, she laughs, agrees and runs to get the Biscotti!

Italian Teacup and Chaos. In St. Mark's Square, Venice, bird seed is flying through the air as parties of pigeons land on and depart from our arms and heads.

Tullia and the Italian teacup. When she and her husband said "Arrivederci" to Italy and "Buon Giorno" to the USA in 1958, she knew no English. After taking classes and getting a degree in language, she taught Italian and French for thirty years at a Spokane, WA, school. She makes and markets her own spaghetti sauce,

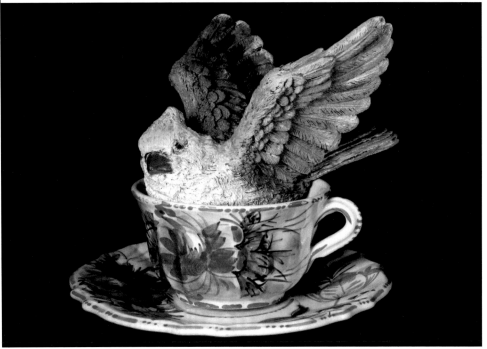

Our family sleeps under a starry night sky on the cliffs of the Italian Amalfi Coast. Suddenly, two flutes start to make the most beautiful music together . . . A Telemann duet at an outdoor concert in the neighboring

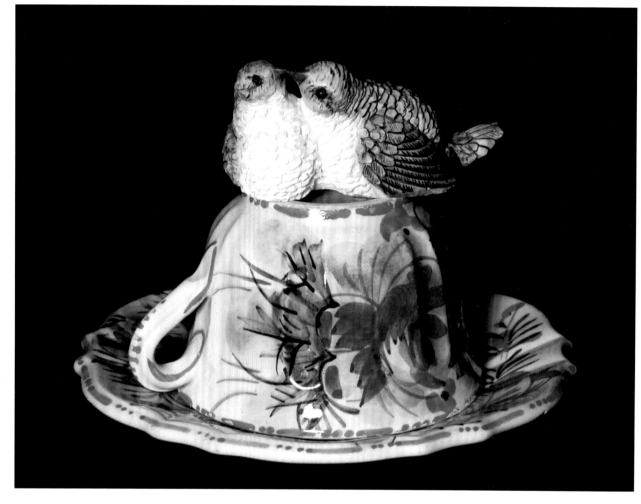

bay. As we lie there mesmerized, I comment to my husband that we should be paying for this serenade. Soon the audience bursts into applause, giving what we assume is a standing ovation, because the flutes repeat their musical delight for the grateful patrons . . . and for us!

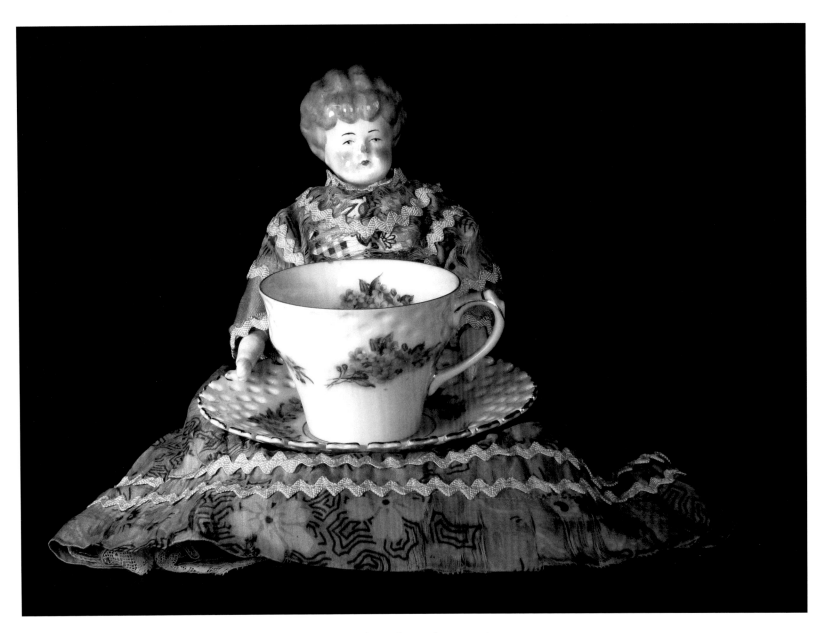

Forget–me-not teacup . . . remembering loved ones.

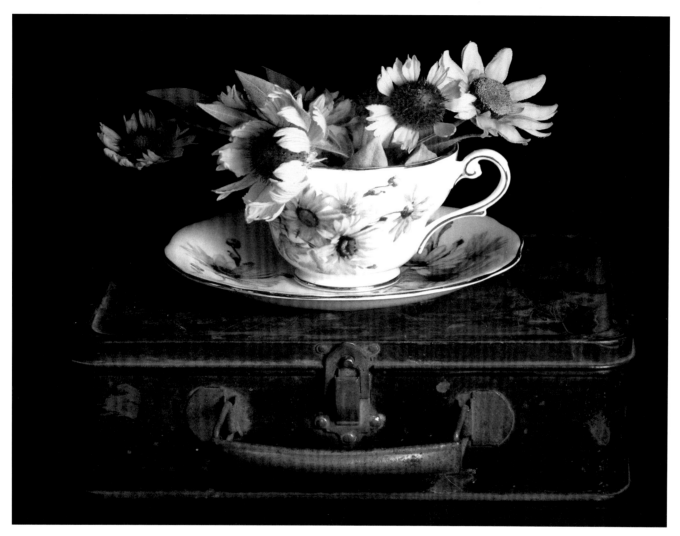

Brown-eyed Susan . . . Maryland's state flower. My husband spent his elementary school years there. He later packed up and relocated to my hometown out west . . . and he did not marry a brown-eyed Susan.

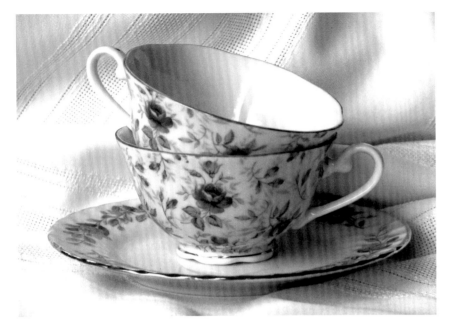

. . . for those who have chosen
to love and cherish each other.

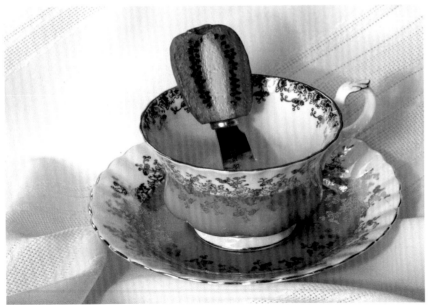

. . . complementing cup and
kiwi.

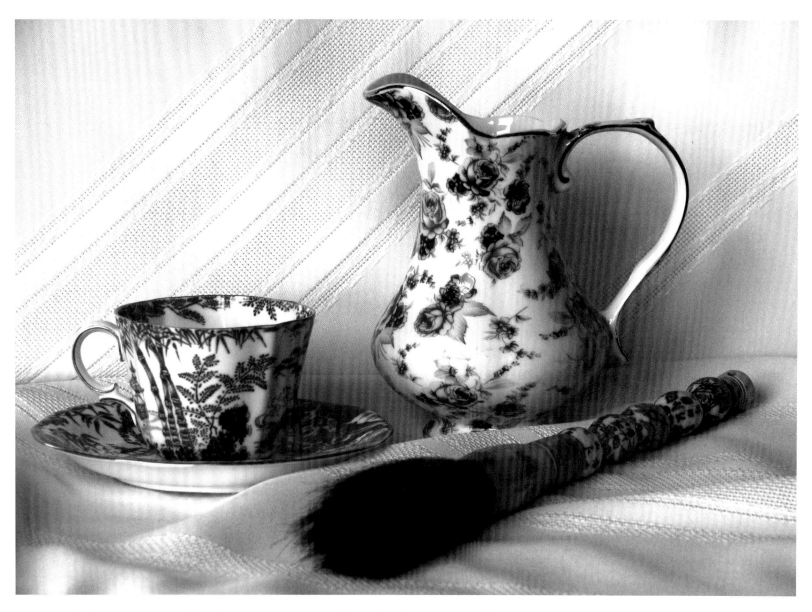

Royal Crown Derby teacup . . . depicting man in a garden tea house.

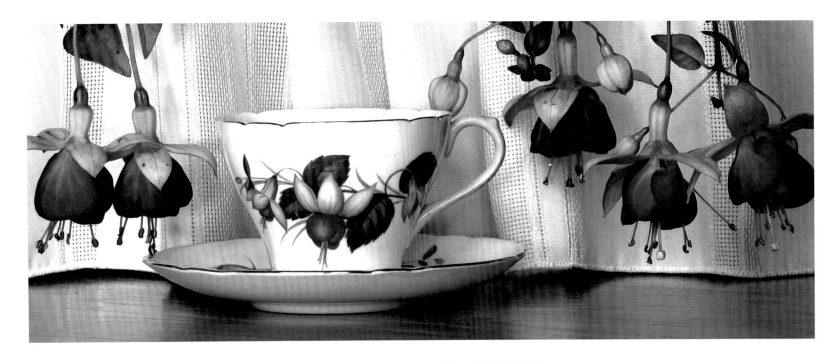

Fuchsia flowers.
My paternal grandma always had a basket of these hanging on her porch.

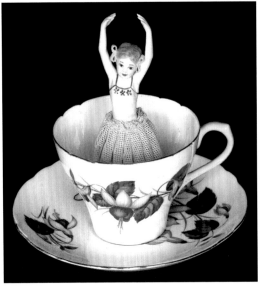

I loved to touch these flowers when I was a kid, and imagine them as dancing ballerinas. (Shelley teacup)

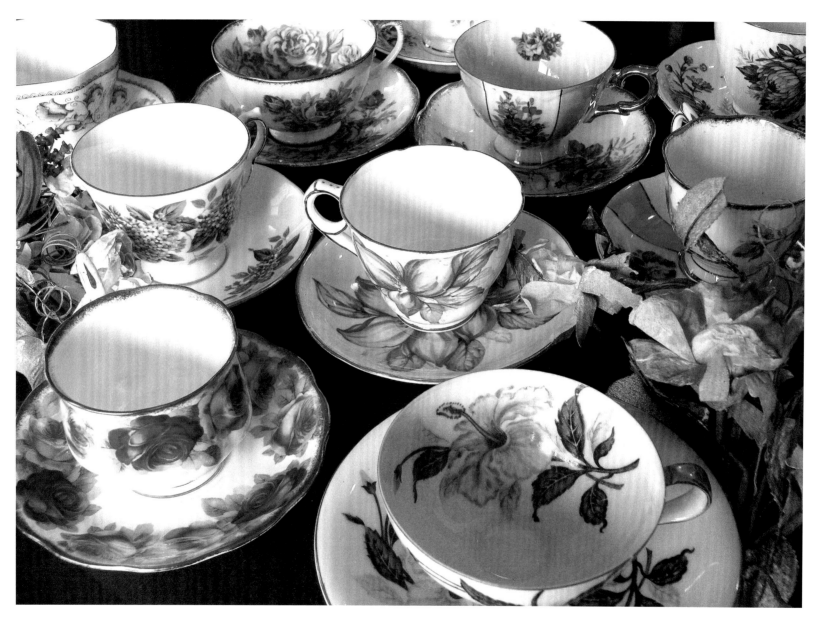

. . . and they gave her a standing ovation.

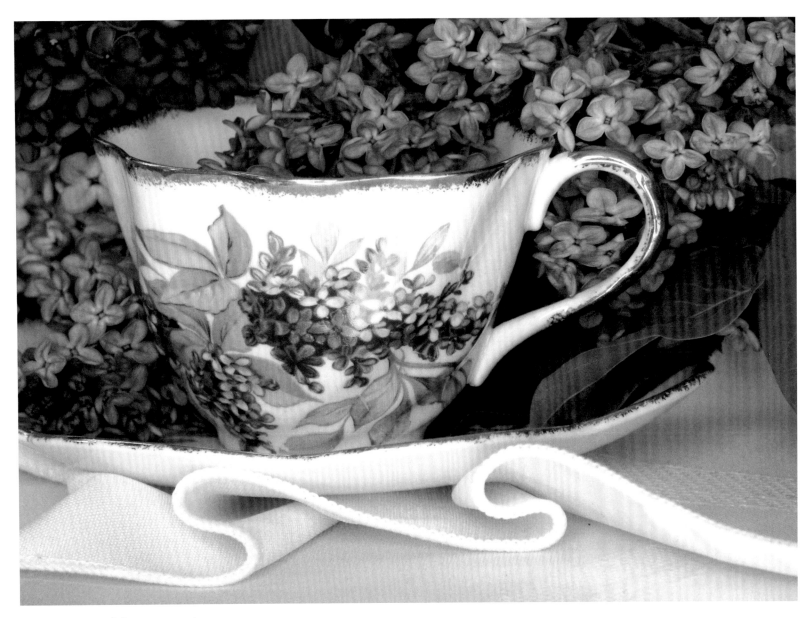

Immersed in scent . . .

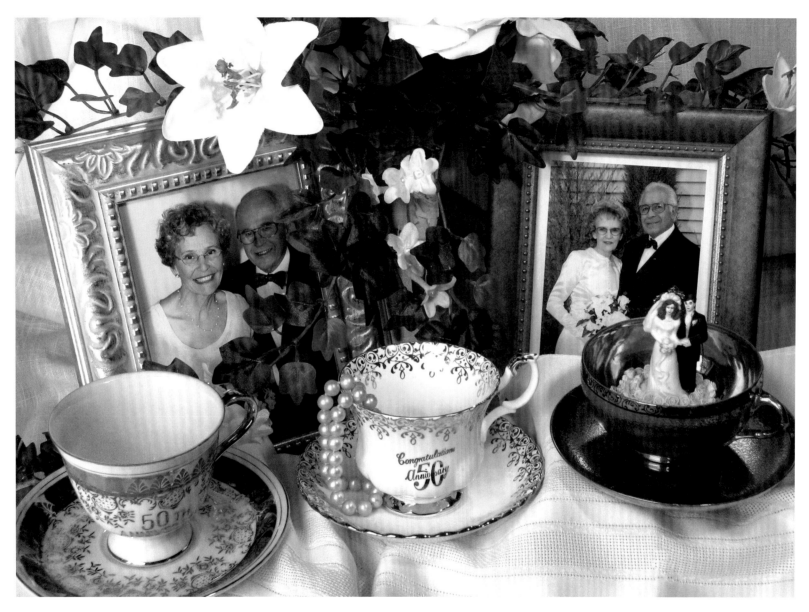

50th Golden Wedding Anniversary teacups . . . a legacy.

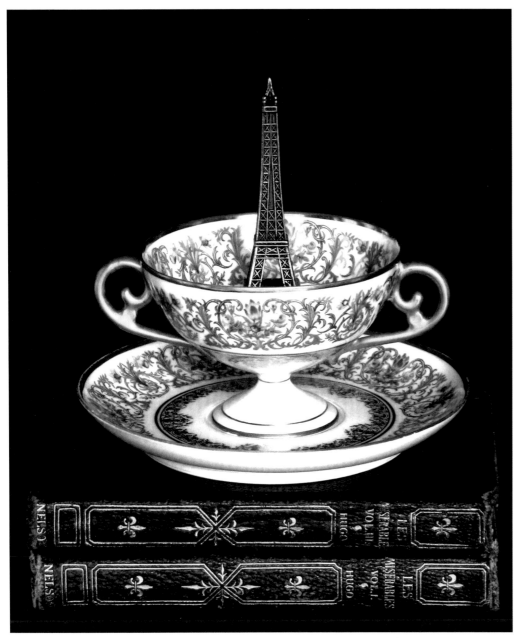

French Cup. The double-handled cup was usually used for bouillon soup.

"J'ai rêvé d'un rêve."
Les Miserables

Rice teacup. Rice is embedded in this teacup and saucer. A clear glaze is then applied to the china. When fired, the rice burns up, leaving only the translucent, glazed-over holes allowing light to shine through.

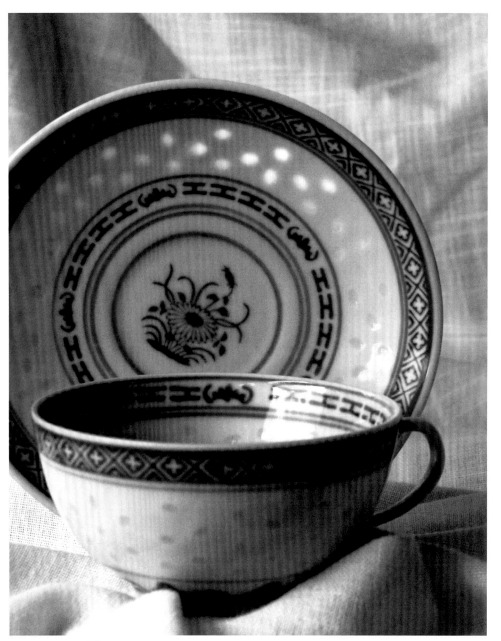

35

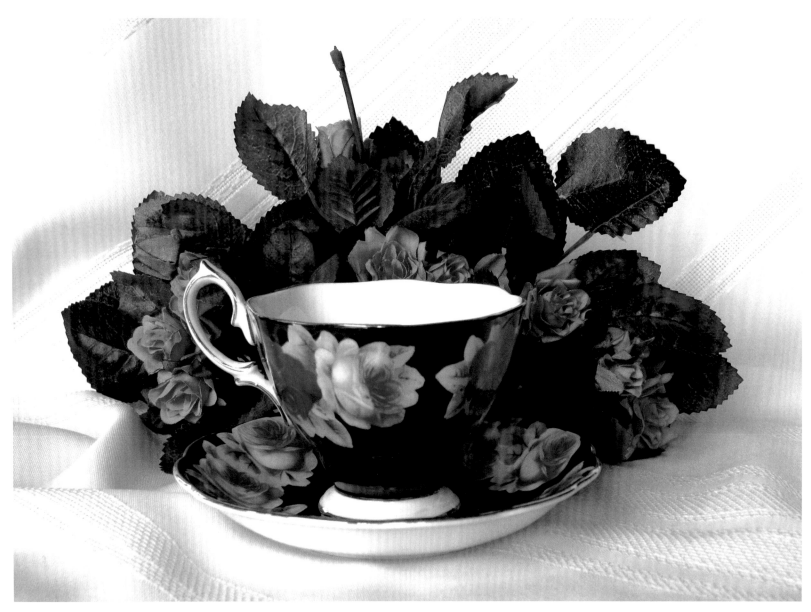

Sometimes it's good to just blend in and observe . . .

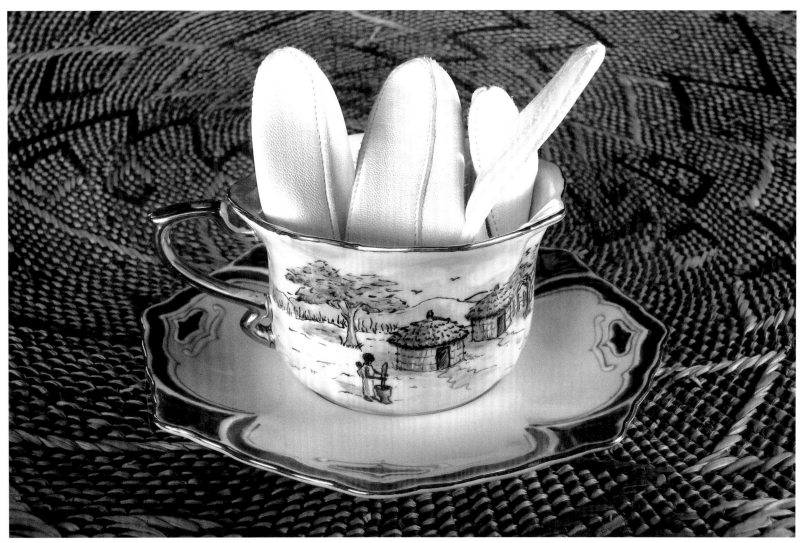

At dawn, an African woman carrying a baby on her back pounds the corn for her morning meal. For many years, white-gloved hands served tea in Africa. Porcelain cup and saucer were hand-painted by Elaine Thompson.

To shelter whiskers
while you sup,

It's best to use
the mustache cup.

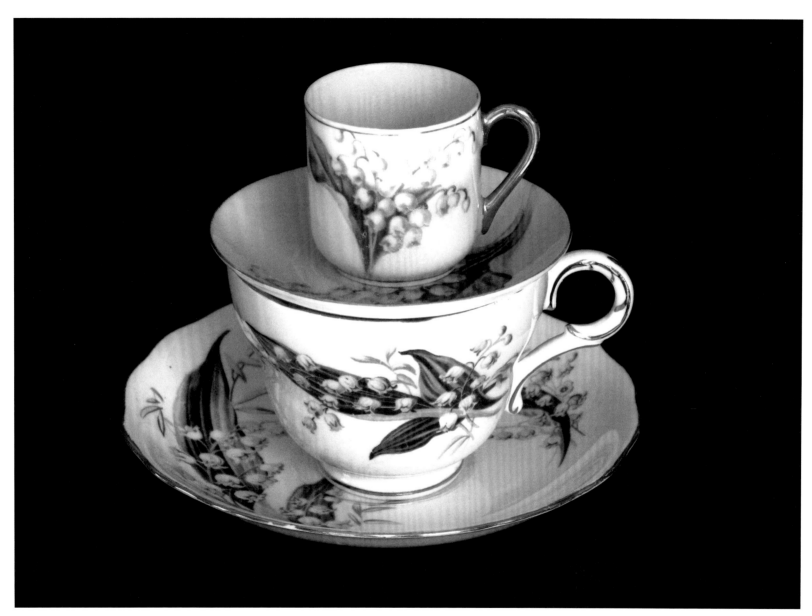

Lily of the Valley tea cups.

Butterflies.
Dragonflies.
Fireflies.
Time flies.

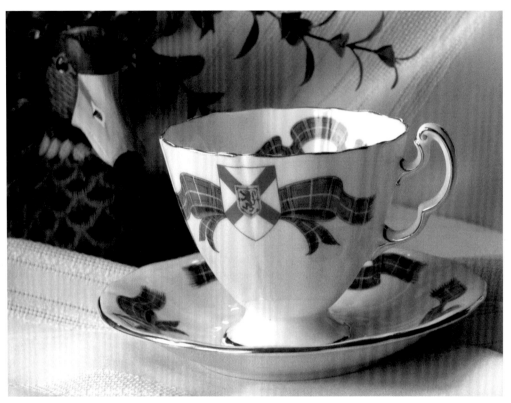

Blue Tartan Nova Scotia teacup.

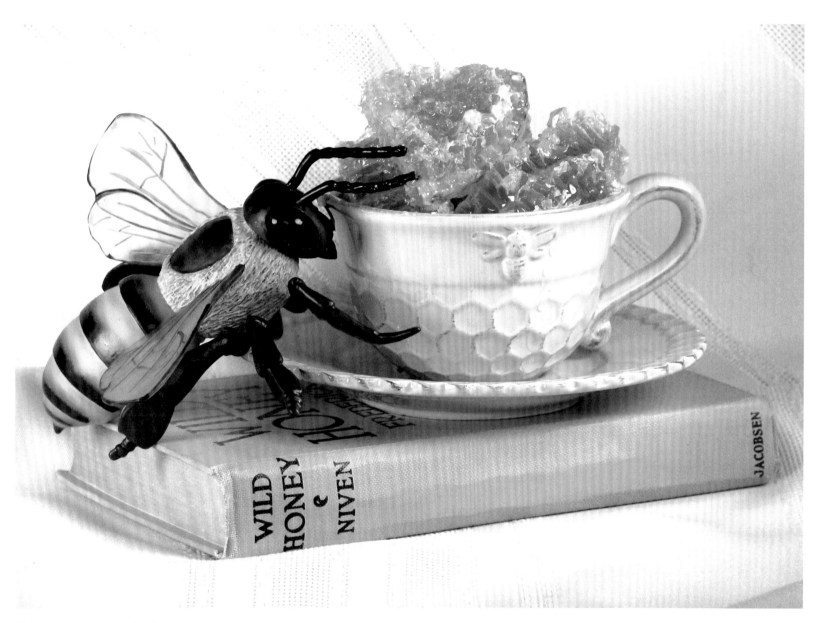

Honeycomb teacup.

Butterfly
teacup
by Franz.

A visiting neighbor come for tea . . . and helping himself to lunch as well!

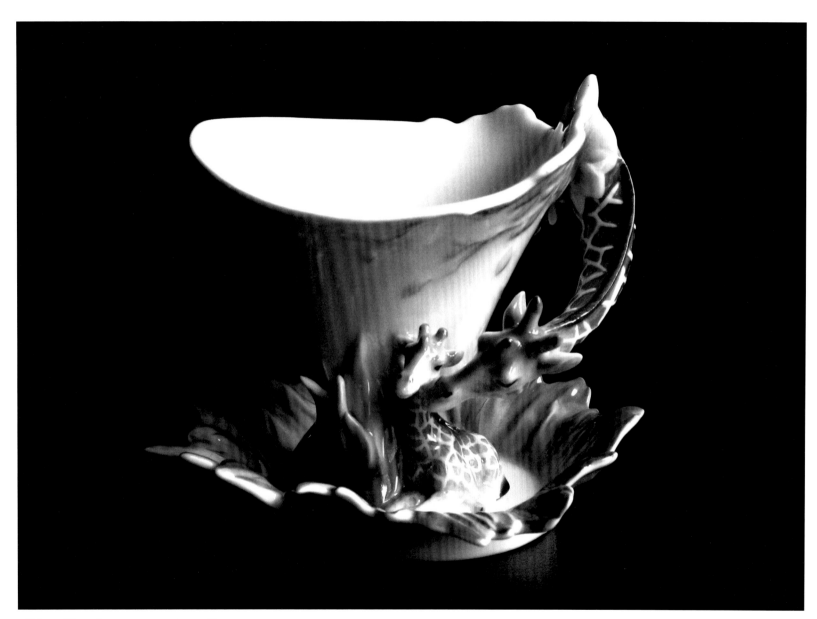

Giraffe teacup by Franz.

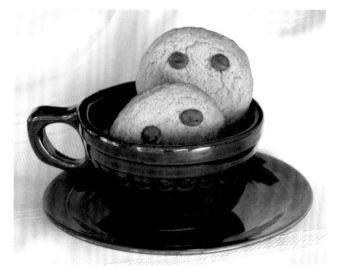

Two is better than one . . .

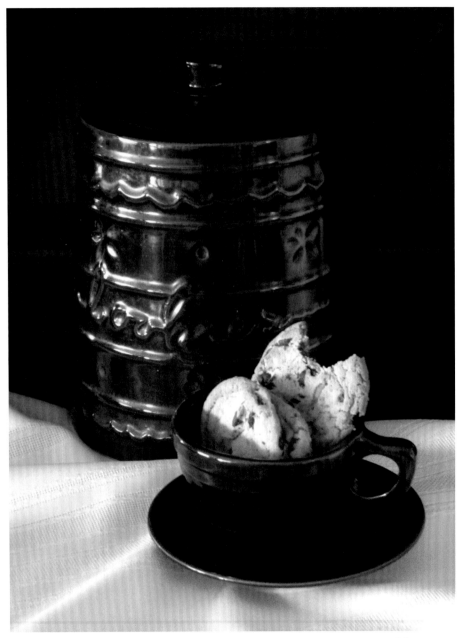

The cookie jar that lived with us
When I was a kid.
We knew Dad was snitching
By the "clunk" of the lid.
And we'd yell, "Daaaad!"

"Made in Occupied Japan" *teacup.* I was made in Japan. My father married my mother three weeks before he was deployed. My mother remained in Los Angeles and joined him six months later. They lived in Japan for eighteen months, and then returned to California where I was born. "Made in Occupied Japan" was printed on pottery, toys and other goods during the American occupation of Japan from 1945-1952 after World War II.

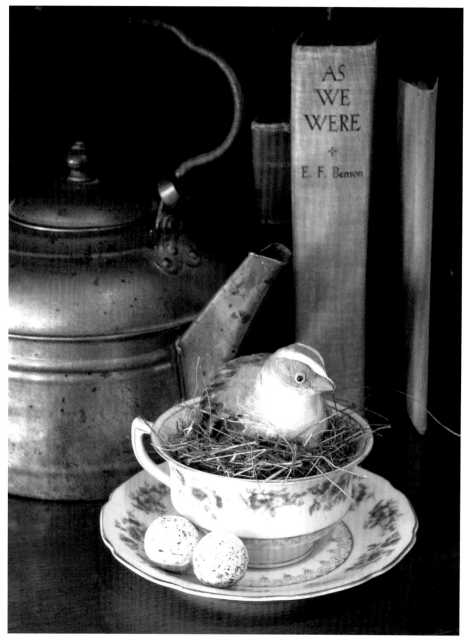

Chai tea in the Chocolate Apothecary, Spokane, WA. I worked a day in the shop with owner Susan, and what a lovely ambassador of compassion and generosity she is to her patrons and the community. "This is John. He helps fine tune the workings of the building. Here, John. Have a cup on the house." "Hi Justin! Try this spicy Mexican chocolate we just got in." "Taylor! Nice to see you. Your wife will love this flavor. Take some to her." "Emily, I've got just the tea for you!" Susan's cups fill her shop with warmth, thoughtfulness and con- versation . . . chai, chocolate and chili powder.

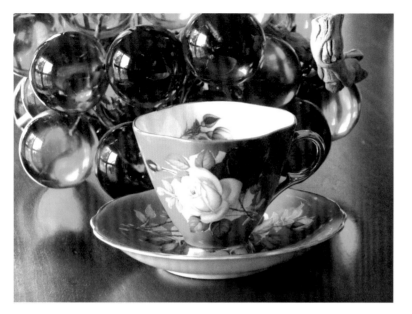

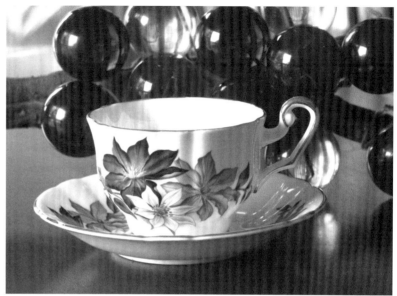

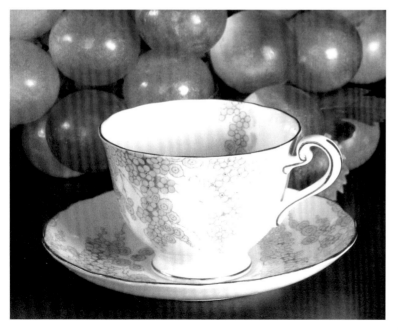

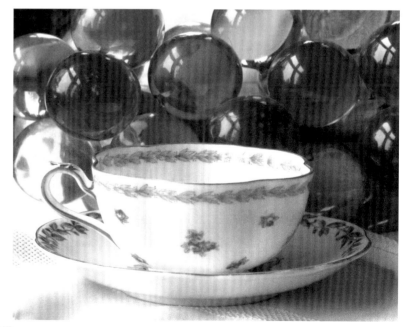

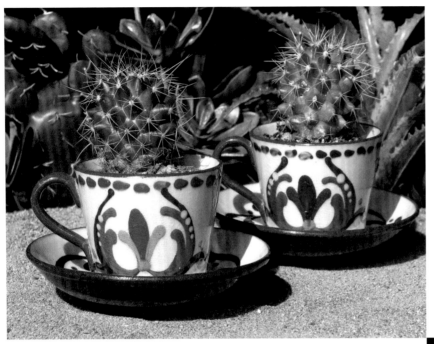

Torquay Mottoware. Placed in a desert setting to remember my maternal Mexican "Granny". . . a snake charmer in the circus, beautician, obstetrical nurse, shoe saleswoman, chicken farmer, flower grower, bus driver, foster caregiver, wife, widow and mother of 7 children.

Souvenir Florida teacup. My husband and I lived in Orlando, FL, for several years. Our best "souvenir" from Florida was our first baby.

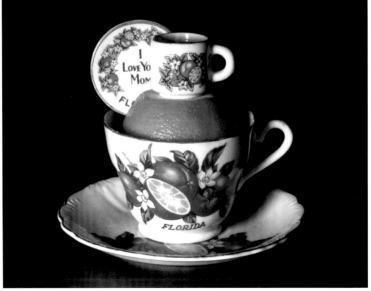

"Flower of the month" teacup series . . . one cup for each month of the year. These belonged to my husband's grandma. She was a refined and proper young woman, a hat maker living in New York City. Her life changed course when she married a rough-cut farmer from Delaware, who swept her off to the country to help run the family farm. Course changes can often lead to the unexpected. Do you have a story?

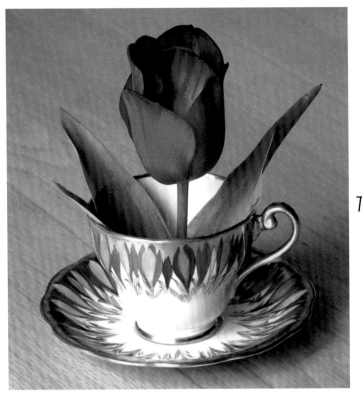

Tulip Teacup

Mount St. Helens made-of-volcanic-ash cup. On May 18,1980, 8:32 a.m., the mountain erupted in Skamania County near Seattle, WA, blanketing Eastern Washington and North

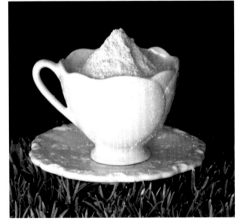

Idaho with ash. Fifty-seven people were killed, and two hundred fifty homes were lost. Fresh landscape rose from the ashes, as well as souvenir art using ash. Do you own some ash art?

Shelley teacup. Pictured is just one of the many patterns and colors of cups that Shelley manufactured. They demand a high price tag. This one was gifted by cousin Dona, the elementary school teacher. When she visited, I took her through an antique store to look at teacups, and I mentioned the highly-prized Shelley brand cups . . . of which I had none. She shared that her grandmother had left her a set of 12 Shelley teacups. My mouth dropped and I delighted at her good fortune. As we continued to browse, I spotted a cup made by Shelley, and quickly called her over to see. She exclaimed, "That is the pattern of cup that my grandma left me!" We laughed at the coincidence. She returned home, and after a few days, I received a letter and package in the mail. This is what the letter said: "A few years ago, the wind caused one of my 12 teacups to break. My mother and I each purchased cups to replace it. Because you are collecting cups with a story, I'm sending you this package. Love, Dona." So here's the math equation: (12 cups - 1 broken cup) + 2 new cups = 13 cups. That was my lucky number, because she gifted me with number 13 . . . a valued surprise with a story!

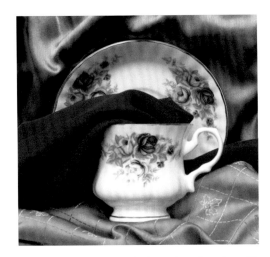 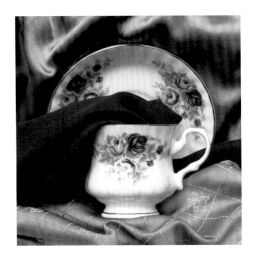 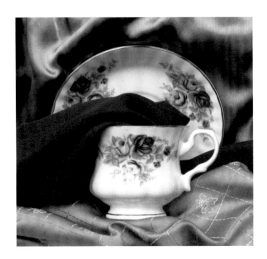

Made in India teacup.　　　*Guest . . . Friend . . . Family . . .*

I scooped up soil
To fill this cup,
And a surprise dangled
From the earthen lump.

Some ideas just fall in
your lap . . . or cup, as
it were.

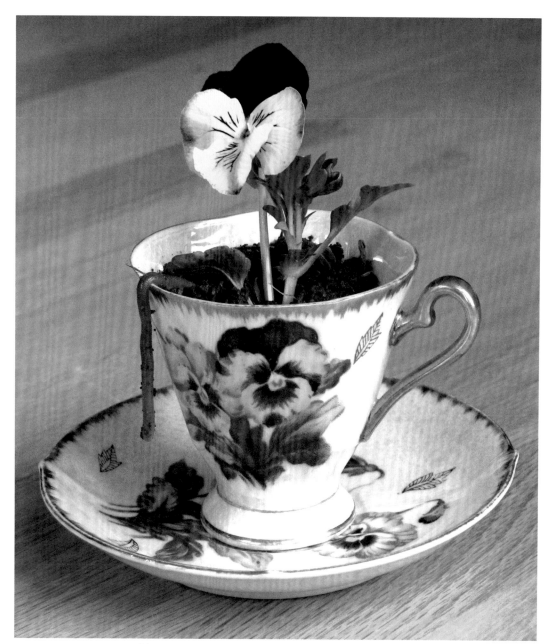

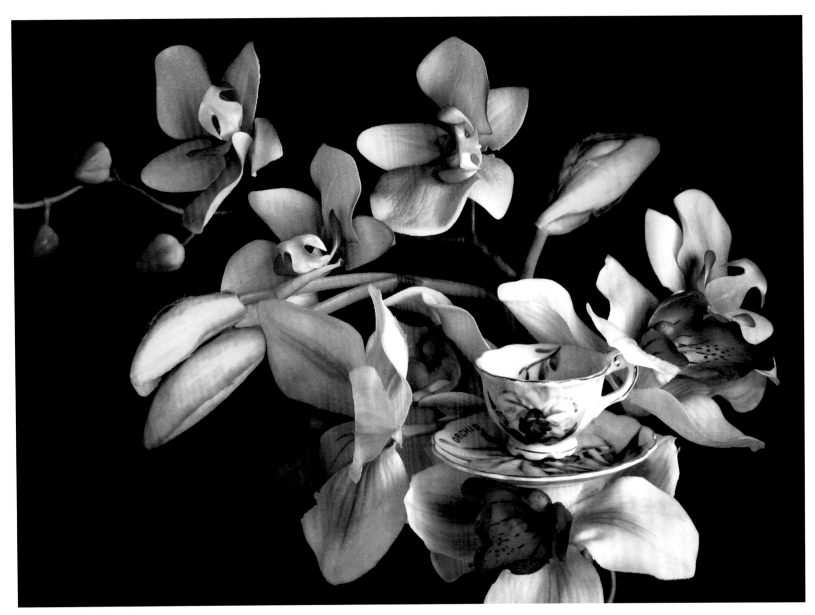

Orchid teacup.

Hawaiian Hibiscus.

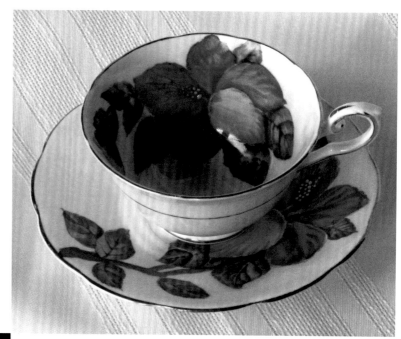

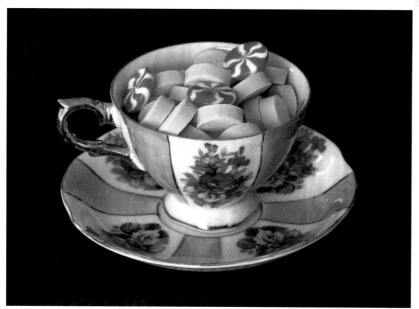

Tea . . . my treat!

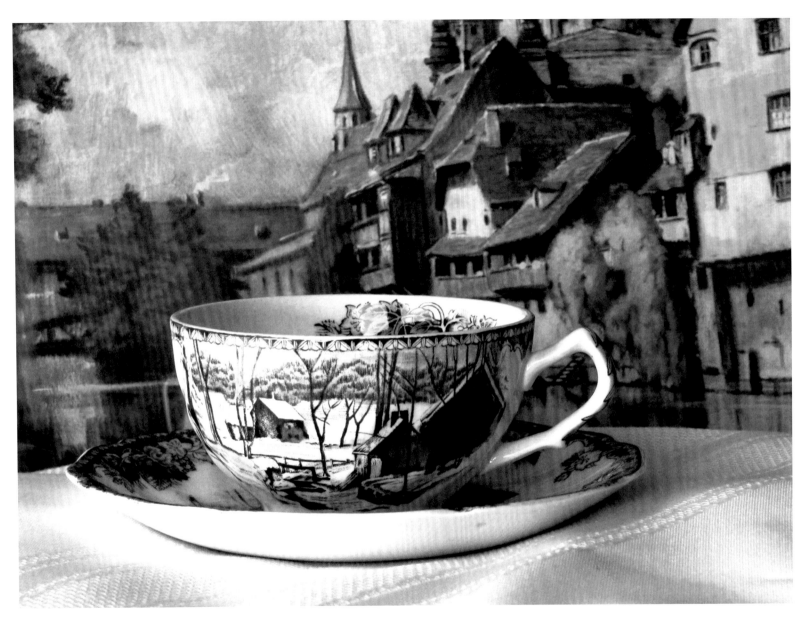

The Friendly Village.

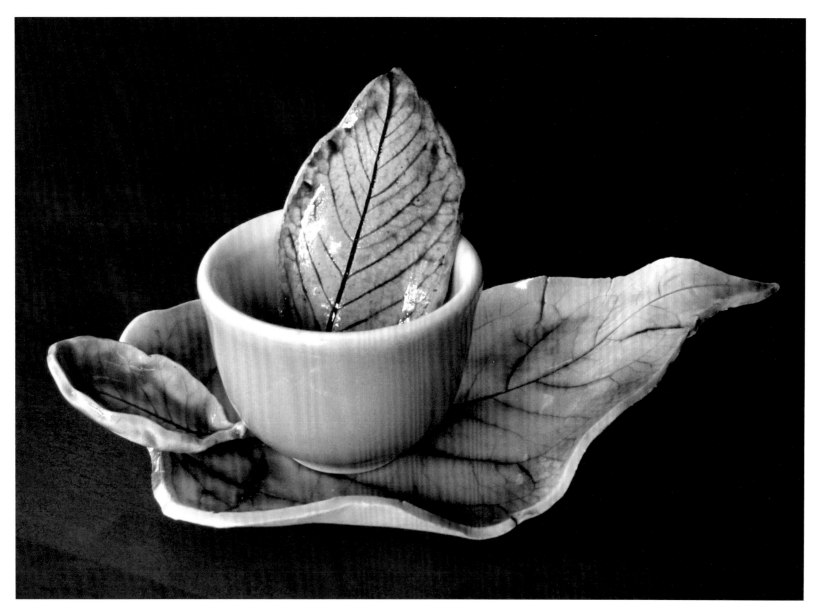

Leaves of three, let them be . . . unless it's tea.

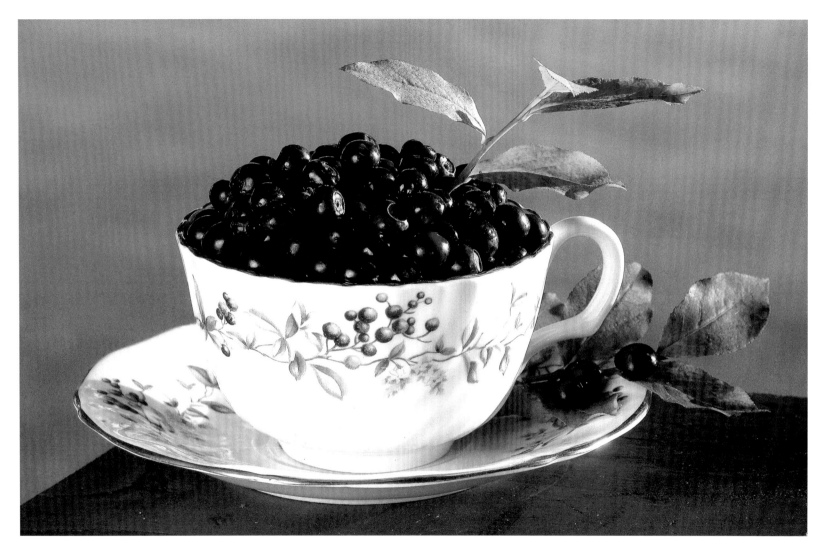

The regal huckleberry, it's bounty rare. We do compete with friend and bear,
To gather all that's found out there. Stains hands, pants—most everywhere!
I hope there is enough to share . . .

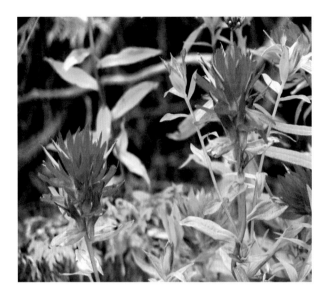

Indian Paint Brush Teacup.

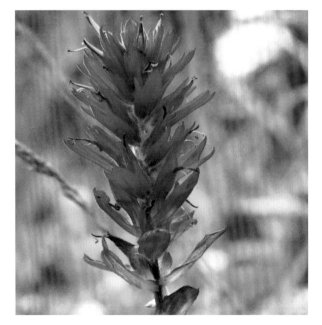

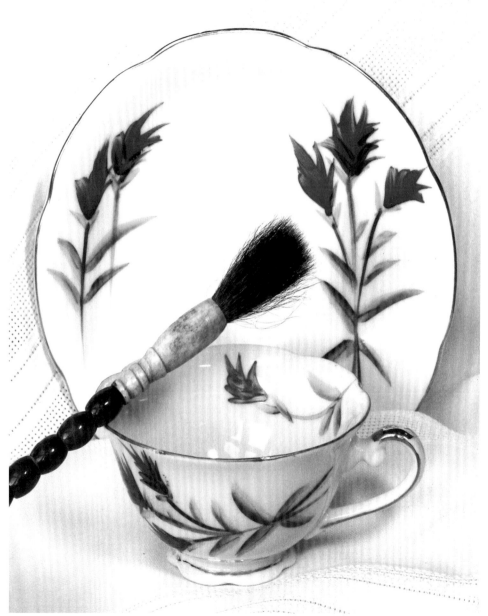

59

In the summer of 1976, a friend and I worked with the beautiful Inuit people in the river village of Selawik, Alaska, located on the Arctic Circle. One of our responsibilities was to feed and care for a rambunctious dog team. Because I had been viciously attacked as a child by a German Shepherd, my friend graciously offered to assume the dog jobs. I would gut the fish.

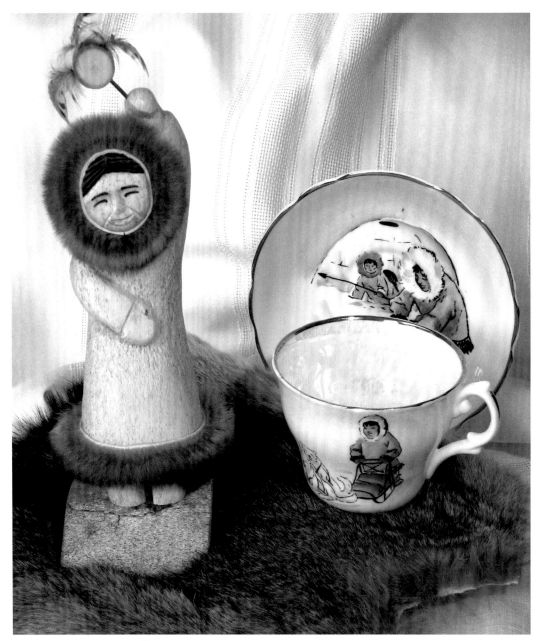

Matthew Adams teacups. River fishing with our new Inuit friends was a delight- ful experience. Days stretched forever in this land where the summer sun never sets.

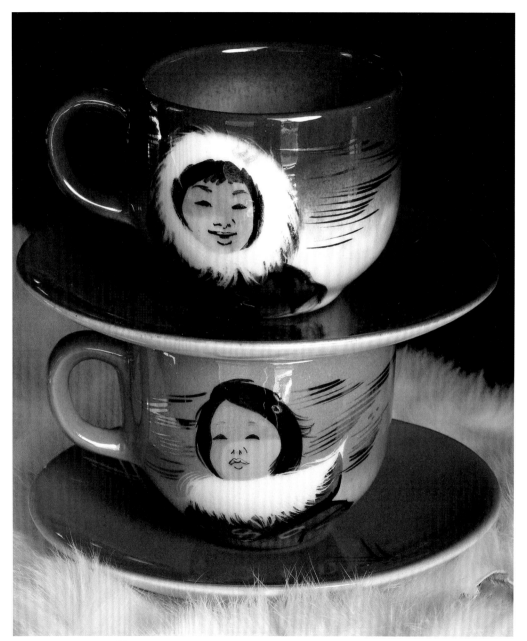

Bluebell teacup . . .

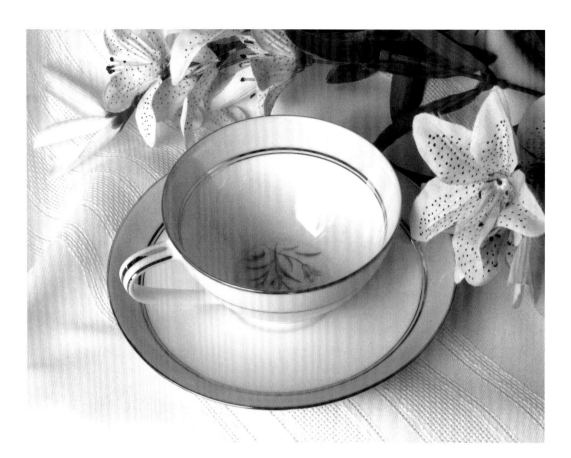

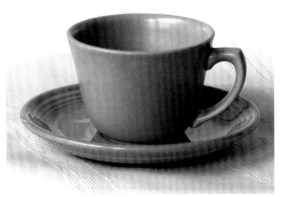

Old Bauer teacup. We visited a historic ranch in Long Beach, California, and Bauerware filled the kitchen. A collector's prize, this pottery became so popular that the factory reopened and started making it again in new colors. "Married" to the cup is an old, ringed Fiesta saucer.

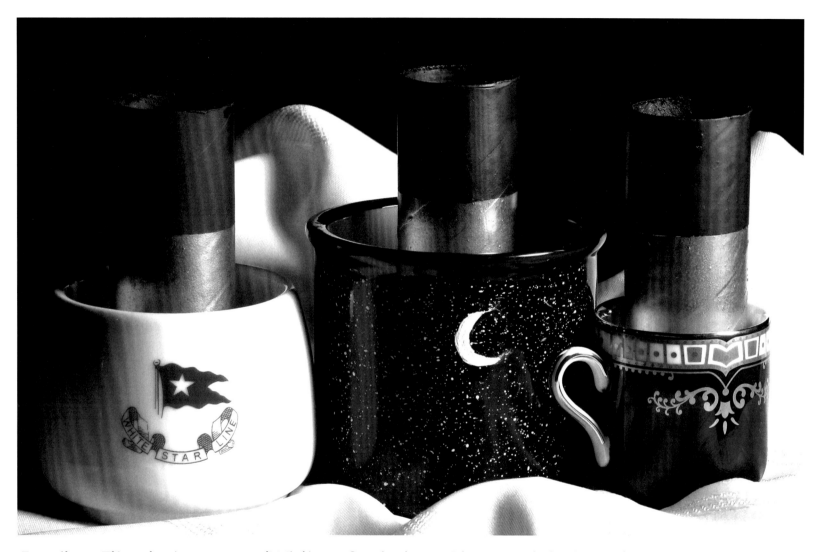

Replica Titanic teacups *(White—2nd class. Blue and Gold—First class)*. Four days into the Titanic ship's maiden voyage, shortly before midnight, the ship struck an iceberg, sinking 2 hours and 40 minutes later on April 15, 1912.

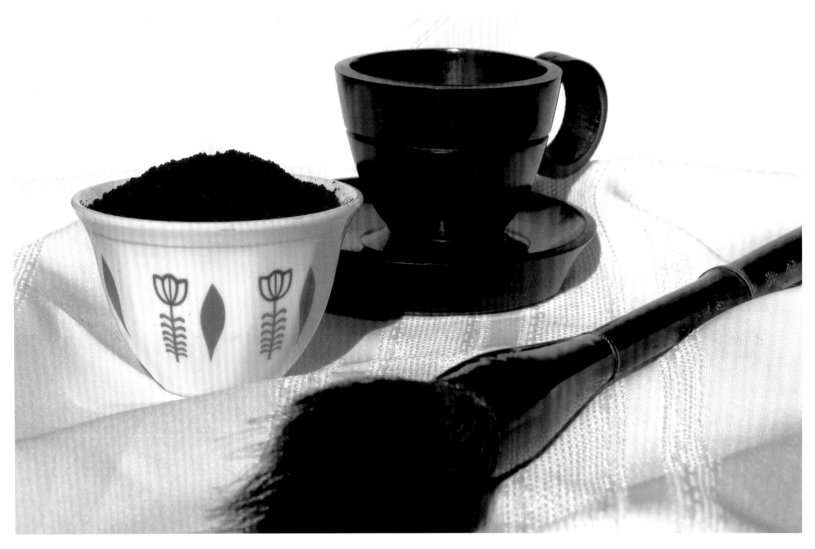

Ethiopian cup (white) and Zanzibar cup (black). Let's paint a portrait of balance, tolerance, love and understanding . . . working together to bridge the gaps.

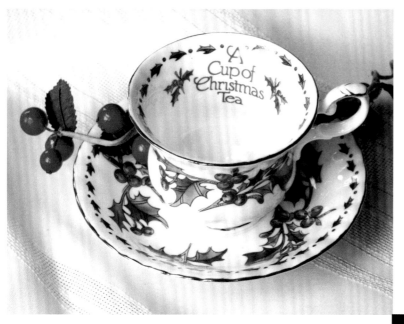

A Cup of Christmas Tea written by Tom Hegg and illustrated by Warren Hanson. This is the poetic, heart-warming story's signature teacup and saucer.

The Twelve Teas of Christmas written by Emilie Barnes and illustrated by Sandy Lynam Clough, also designer of this signature teacup and saucer.

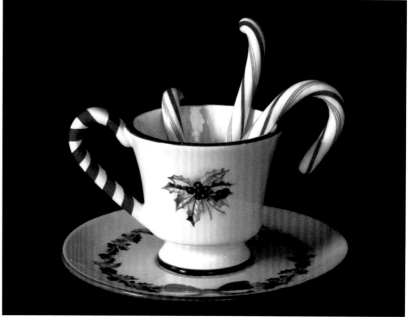

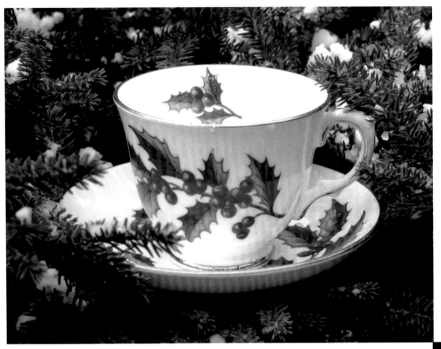

This holly teacup is the only one celebrating a late April snowfall.

If through life you may be damaged,
Cracked, burned, tossed or hurled,
Take some time to heal and mend,
And know you still can light your world.

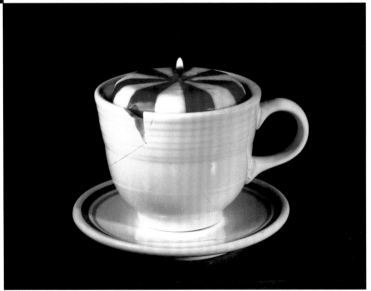

December Flower of the Month Series.

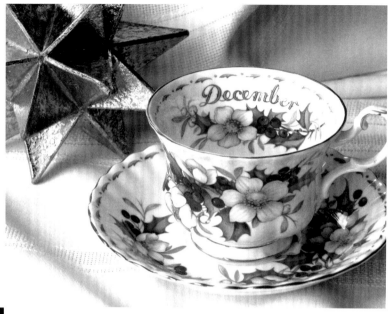

Blooming Christmas Cactus. If you were going to make your debut only at Christmastime, what color would you wear?

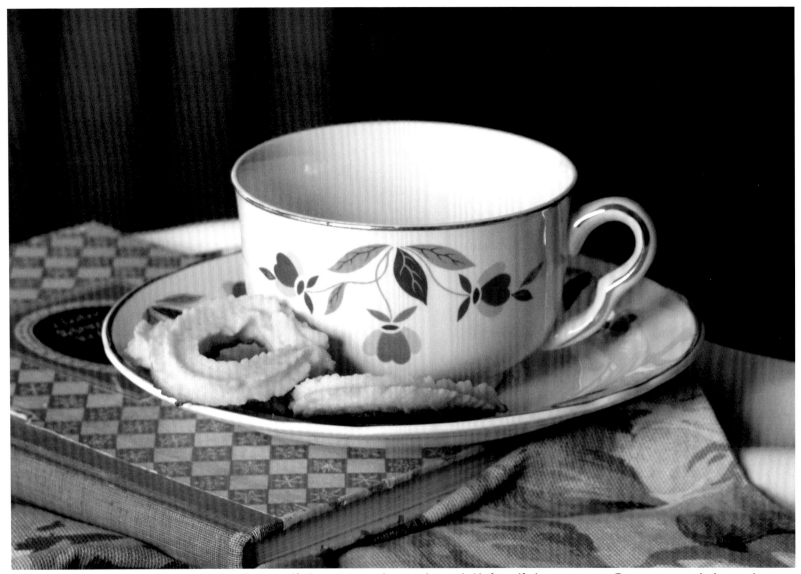

Jewel Tea teacup. My Swedish grandma had this dishware. One could get these dishes in cereal and soap boxes. Her cookbook awaits the next meal.

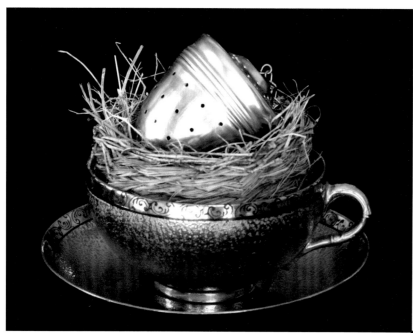

Golden teacup.

Tobacco Spit Glaze teacup.

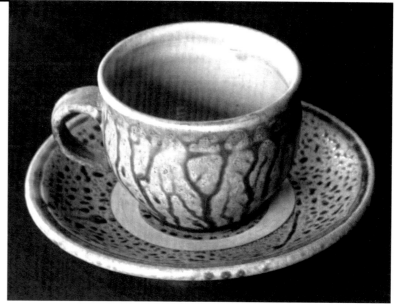

69

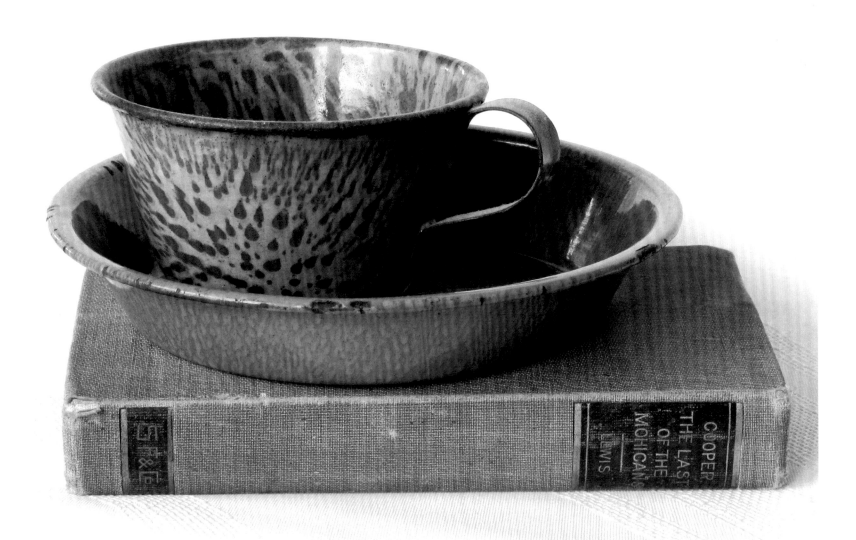

Graniteware teacup. This cup from the "old west" was durable, and could be used by the open fire. How many pioneers' hands have held this cup?

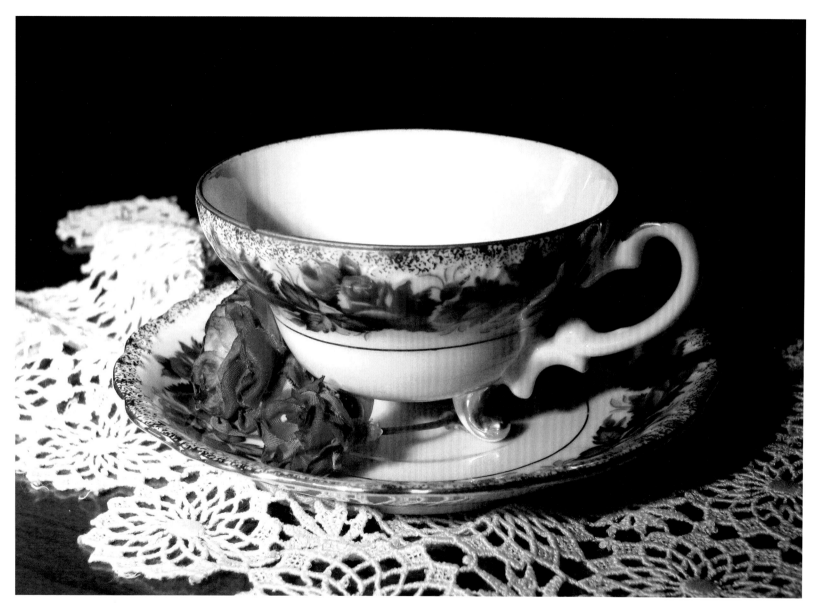

Dressed for an elegant evening.

(Belonged to my paternal grandma.)

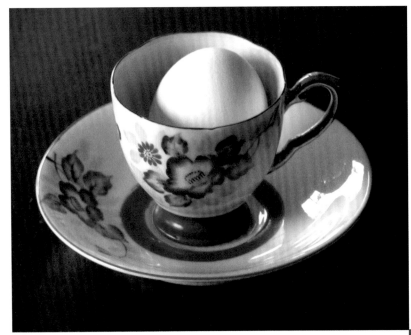

Made in Occupied Japan teacup.

New Zealand cup and the Pukeko bird.

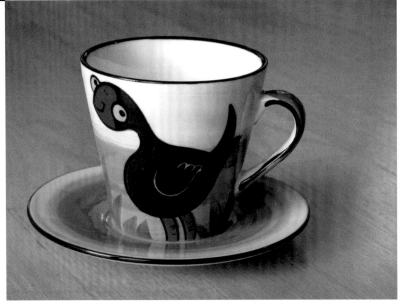

Wild, exotic,
 tropical leaves,
Painted shades
 of yellow-green,
In golden splendor
 camouflage.
What bits of life
 remain unseen?

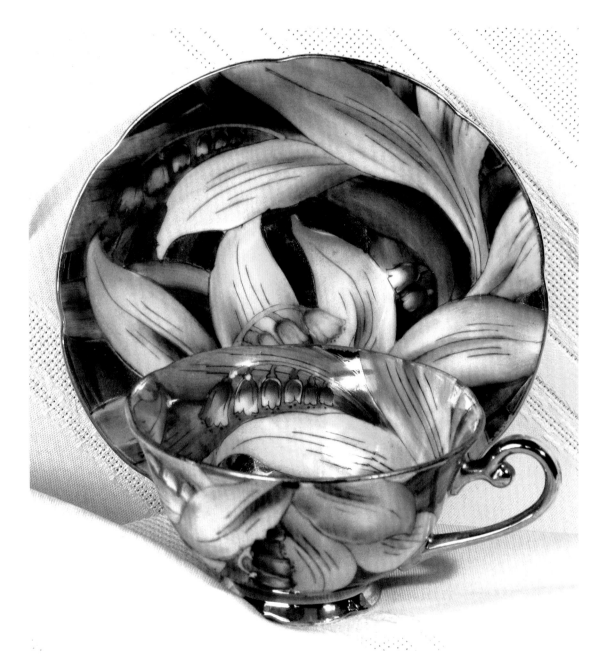

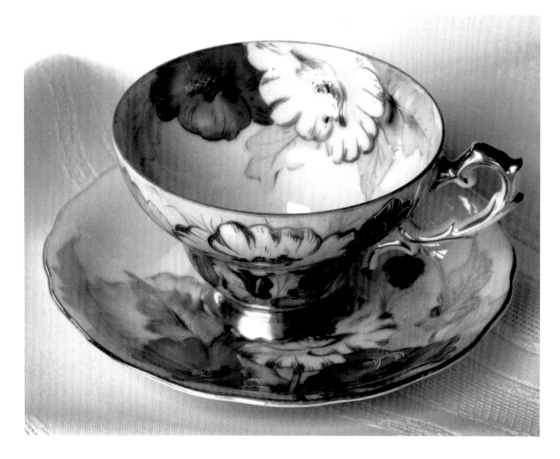

Do you wonder,
 as you sip and savor,
Why artists paint with
 emboldened brush
The vibrant tones of
 darkened cherry,
Ocean blues, pink rose
 and such?
Perhaps to thankfully
 greet the day,
And steep your morning
 with a creative touch.

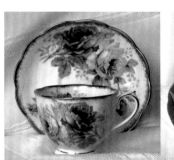
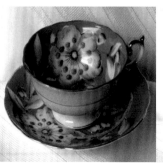
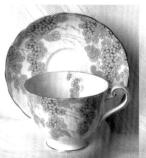
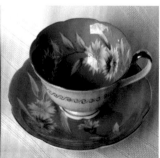
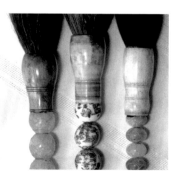

How many
hands
have held
this cup?
Spooned
out sugar
to slowly
stir,
And raised
the
simmered
tea to
sup?
How I
wonder
who you
were.

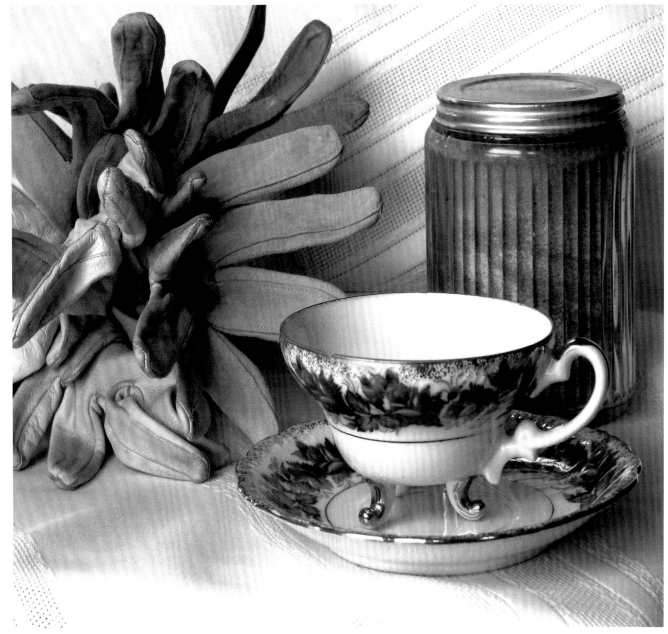

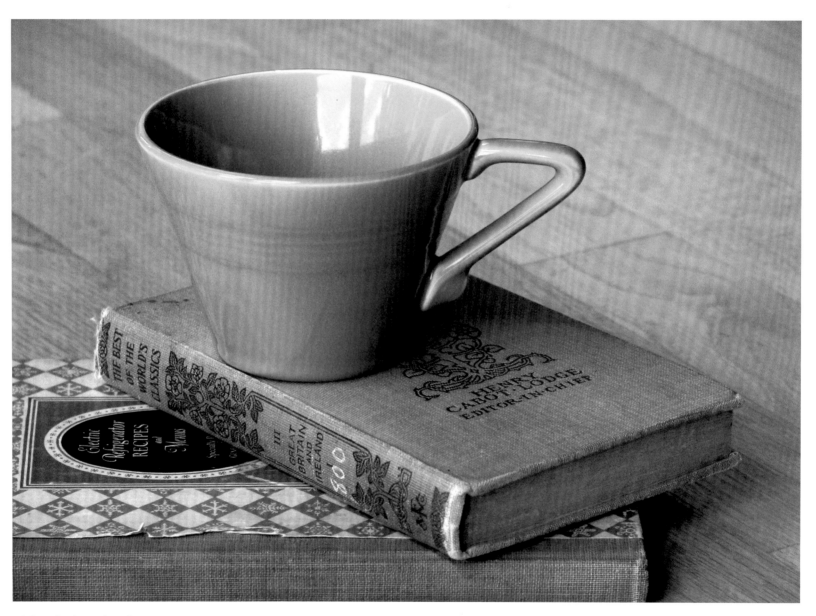

Harlelquin teacup.

This story tells of teeth
and tears,
One fateful pitch and
swing.
Those who craft new
pearly whites,
To you our praises
sing!
Do you have a story?

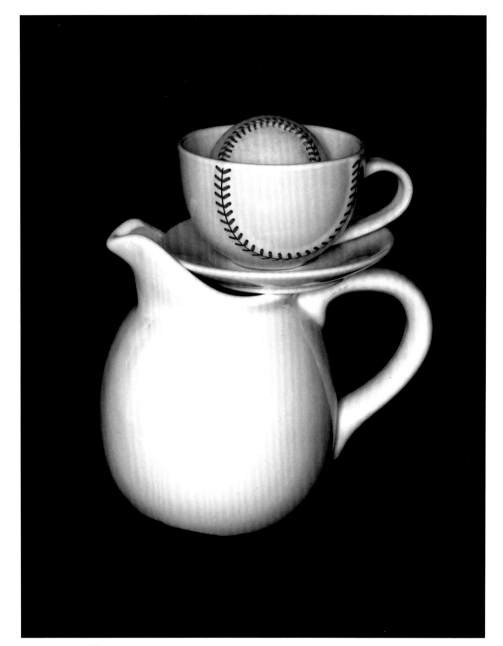

Orchard teacup.

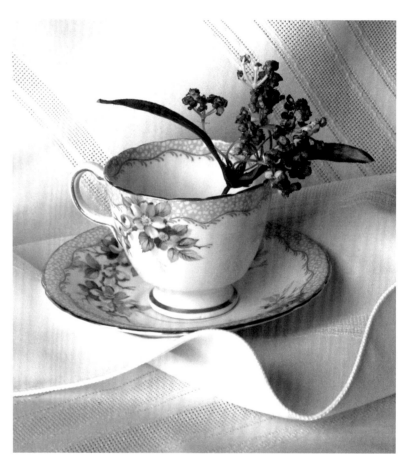

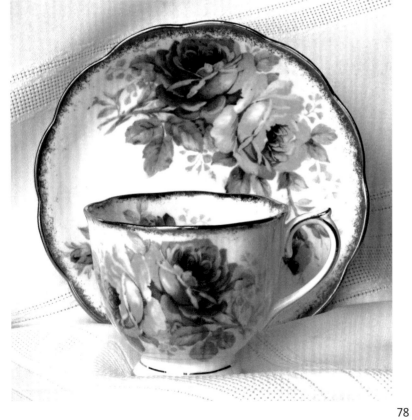

American Beauty teacup.

Mingling green . . .

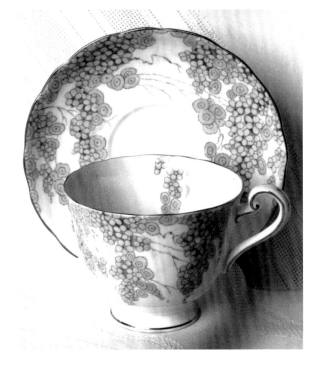

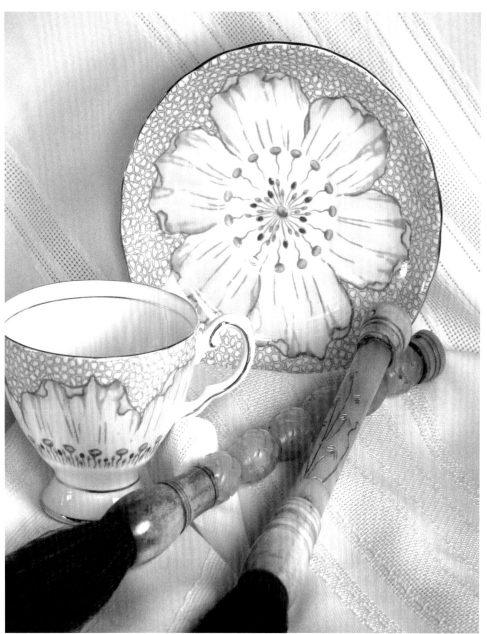

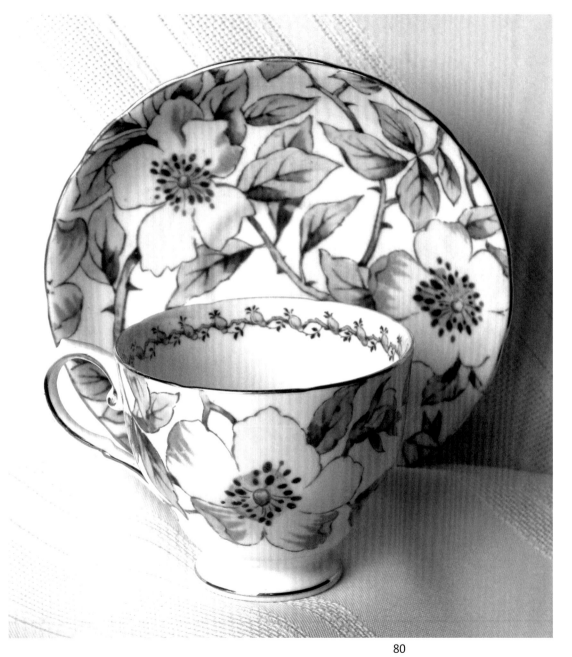

The highest bid . . .

I saw this cup and saucer displayed in an online auction, and I fell in love with the cup's unusual flair. There were 11 people already bidding for it. This was a popular teacup. I jumped into the auction. As the minutes counted down, the bids were flying up in dollar increments. "Congrats, you are the highest bidder." "Sorry, you've been outbid." I REALLY wanted this teacup. Now in the auction's final seconds, I saw my finger frantically hitting the computer key to raise the bid as adrenalin surged through my body. At last, the message "Congrats, you've won this item!" printed across my screen. I shouted, "YES!" to nobody listening in my empty house.

As I reveled in the moment, the thought occurred to me that the Creator may feel just like this as He earnestly bids for our lives . . . bidding with truth and love. Knowing that there are other bidders, He desperately offers the highest price. And just maybe He yells "YES!" to the listening universe when He wins our trust.

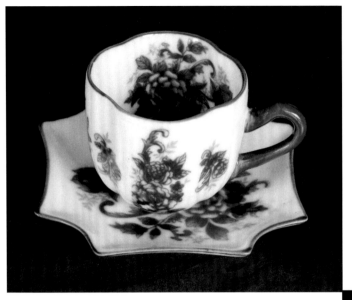

After being lost for a year in a bag of scrap fabrics, this cup and saucer was discovered, rescued, and given it's rightful place.

For those who have children, take care of children, treat children, rescue children, teach children, support children, feed children, practice with children, tickle children, write to children, sing to children, drive children and pray for children. Much nurturing is required to grow children.

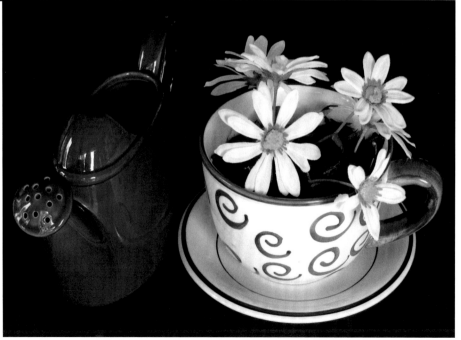

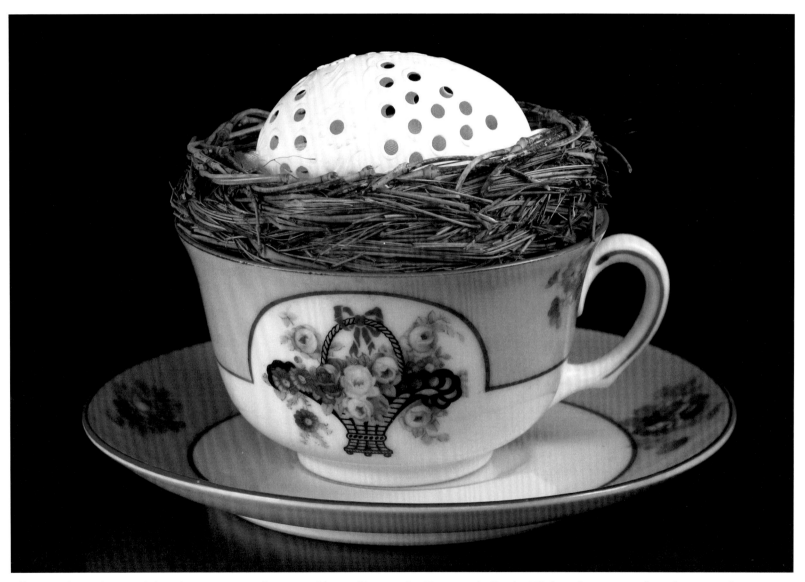

Czechoslovakia teacup (now the Czech Republic). This decorated egg is a handicraft of this beautiful country. "Czech it out!"

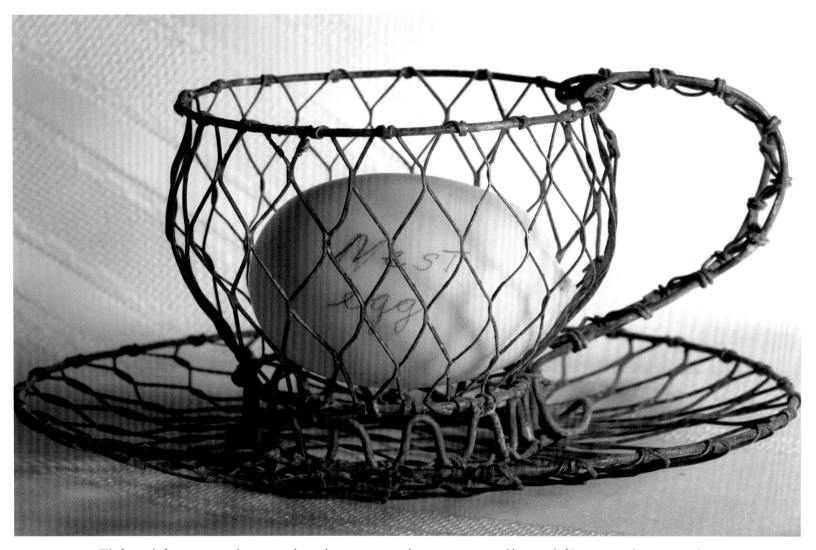

This china nest egg looks so real, so smooth, white and round.

Trains hens to lay their eggs in nests, instead of on the ground.

Where do you keep your nest egg?

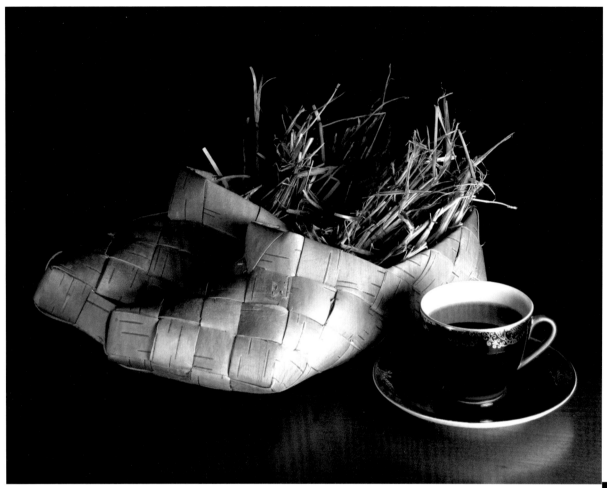

Russian Teacup.
At Christmas-
time, the Rus-
sian, hand-
woven, birch
bark shoes are
placed on the
doorstep and
filled with hay
for the reindeer.

USSR Teacup.

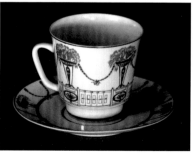

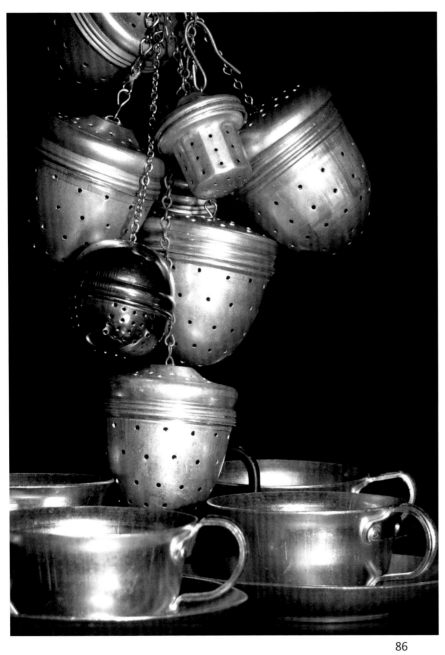

Tea Chime . . .
Tea Time . . .
Tea Rhyme . . .

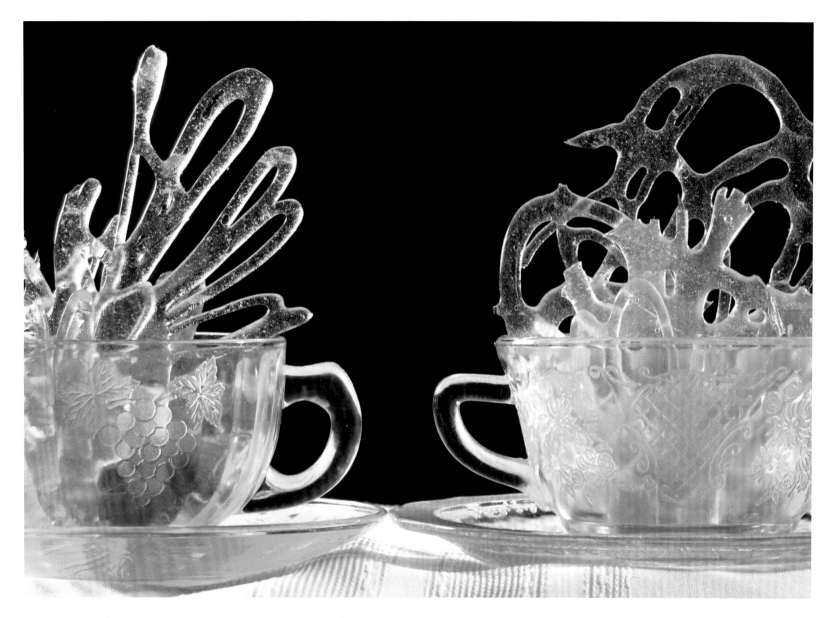

Depression Glass meets euphoric candy.

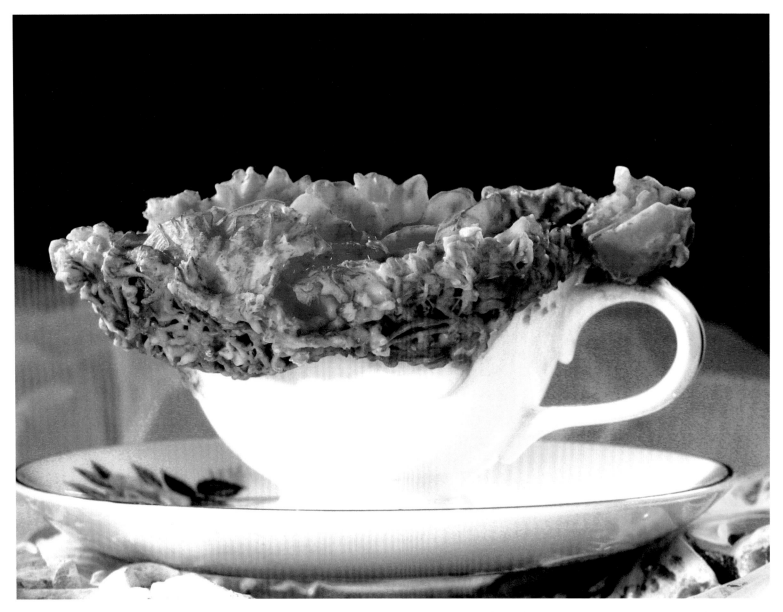

Chocolate Flowers by Paula Richards, award-winning chocolate designer.

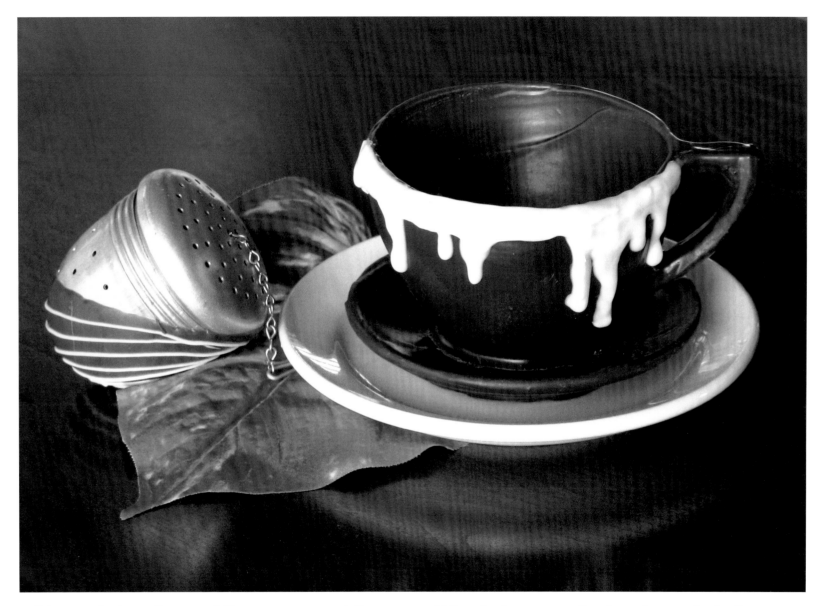

Chocolate-dipped Teacup and Saucer. What do you dip in chocolate?

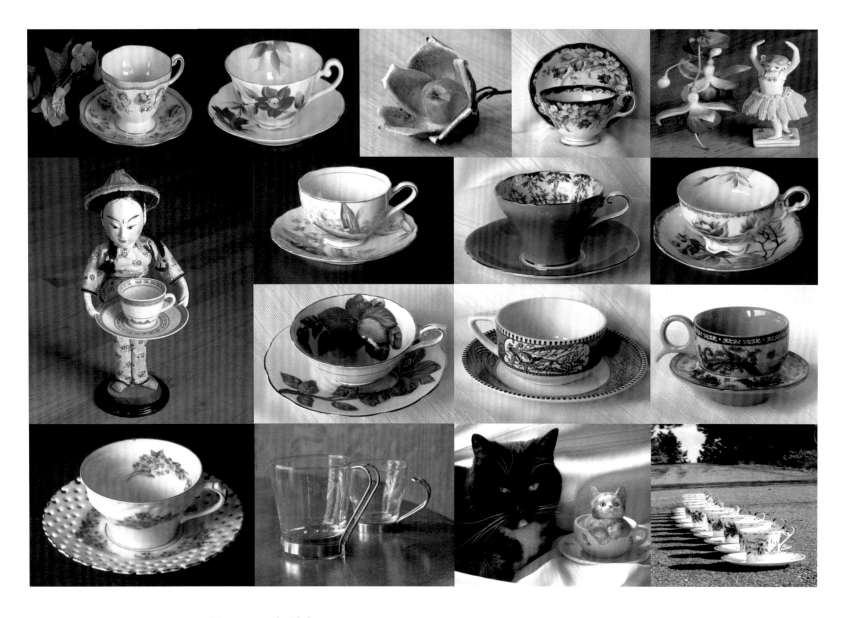

From all walks of life, we each have a story . . .

Acknowledging the Creator, the Master Artist, who inspires . . .

. . . and fills my cup.

Index

Information

1—Harlequin Teacups. Produced by Homer Laughlin China Co. in 1936. Medium green was a limited run color in the late 1950's. Art Deco style.

2—Franciscan Ivy. Franciscan Pottery, as it was first named in 1934 , was manufactured by Gladding McBean in Glendale, CA.

3—Liberty Blue. Historic Colonial Scenes. Old North Church. Made in England.

4—Marjolien Bastin Teacup. Permission by Mischa Bastin.

5, 6, 7—Austrian Teacup. Imperial Crown China.

8—Wooden Teacup. Inlaid wood. Artist unknown.

　—Trick Teacup. Purchased from a furniture store.

9—Mann Musical Cup. Designed by Eda Mann, artist and portrait painter trained at the National Acad. of Art, NYC, in 1920. Cup was manufactured by her husband Seymour Mann and son-in-law Gideon Oberweger. Permission by Claudia Mann.

10—Butterfly Cup. National Wildlife Federation.

11—Mom Cup. Relco—Japan.

12—Credit! Grosvenor China. Made in England. Rutland.

13—Franciscan Desert Rose. By Gladding McBean in Glendale, CA in 1934.

14—Limoges France. Haviland.

15—Heather. Modern California. Made in USA. Vernon Kilns. Authentic California Pottery II.

16—Hawaiian Woodrose. Tuscan Fine Bone China. Made in England.

17—Anthurium. Hawaii.

18—Franciscan Apple. By Gladding McBean in Glendale, CA 1934.

19—Harlequin Green with Utensils. Produced by Homer Laughlin China Co.

20—Chrysanthemum Hands. Gladstone Bone China. Made in England.

21—Sweet Violets.

22—Purple Flower. Hand-painted.

23—Harlequin Yellow. Produced by Homer Laughlin China Co.

24—Tullia, Chaos. Made in Italy Teacup.

25— Two Birds on Amalfi Coast. Made in Italy Teacup.

26—Forget-me-not.

27—Brown-eyed Susan.

28—Love Cups. Gifted by Nilmini.

　—Cup and Kiwi. Royal Albert. Bone China. England.

29—Royal Crown Derby. Made in England.

30—Fuchsia Shelley. Fine Bone China. England.

31—Standing Ovation.

32—Lilac. Salisbury. Bone China. Made in England.

33—50th Anniversary. (L)Norcrest Fine China. (Center)Royal Albert Bone China.

34—Made in France. Gifted by Cindy.

35—Rice China.

36—Blend with the Crowd. Royal Albert. Bone China. England.

37—Africa Teacup. Porcelain, hand-painted and gifted by Elaine Thompson, former missionary to Africa.

38—Mustache Cup. Austria. Belonged to my husband's great-grandfather. Loaned by Terry.

39—Lily of the Valley. Melba. Bone China. Made in England.

40—Blue Butterfly.

 —Nova Scotia Blue Tartan Teacup Gifted by Jenny in honor of her beloved Nova Scotia, duck-tolling retriever "Pilot".

41—Honeycomb Teacup. Produced and permission by Victorian Trading Company. Bee by Safari Ltd.

42—Franz Butterfly Teacup Gifted by Barbara and James. Permission by Franz, Inc.

43—Franz Giraffe Teacup. Gifted by Corky. Permission by Franz, Inc.

44—Cookies. Teacup and cookie jar are Marcrest Ovenproof. Saucer is Early California, Vernon Kilns.

45—Made in Occupied Japan. Gold Castle. PAT.

46—Chai and Susan.

47—Grapes. (Drk. Green) Windsor, England. (Purple) Royal London. England. (Lt. Green) Embassy Ware. Fondeville. England. Olive Green) Crescent. England.

48—Torquay Mottoware. Longpark. England. Various mottos or sayings were etched into or painted on Mottoware by many different artists. Etched into the back of these red clay cups is the motto, "Duee drink a cup of Tay."

 —Florida Souvenir Teacup.

49—Flower of the Month Series. Made in China.

50—Tulips. Royal Stafford. England.

 —Mount St. Helens "made-of-volcanic-ash" Teacup. Ash was a gift from Tim and Karen Schultz.

51—Shelley and Dona. Shelley cup pattern "Rosebud". Dates 1940-1966.

52—India Cup. Belonged to missionaries in India.

53—Pansy.

54—25th Silver anniversary. Elizabethan. Made in England.

 —Pink Trillium. Royal Stafford. England.

55—Hawaiian Hibiscus. Yamaka China. Made in Occupied Japan.

 —Tea My Treat.

56—Friendly Village. The Ice House. England. By Johnson Bros.

57—Three Leaves. Two small leaves by Donna Kulibert.

58—Huckleberry. Mayfair. England. Gifted by Edith.

59—Indian Paint Brush. Norcrest. Japan.

60—Alaska. Winston. England. 22 KT. Gold. Carved art by Vukson.

61—Matthew Adams.

62—Bluebell. Noratake. Japan. These were my mother's first set of dishes.

63—Replica Titanic Cups. Permission by White Star Momentos (white and red cup). Permission by R.M.S. Titanic, Inc. Titanic Artifact Collection (replica blue and gold cup).

64—Ethiopia Cup (white). Zanzibar Cup (black). Gifted by Fletcher.

65—"A Cup of Christmas Tea" Copyright 1982, Tom Hegg & Warren Hanson. Permission of Tristan Publishing, Inc. All rights reserved. Www.tristanpublishing.com.

 —"The Twelve Teas of Christmas" by Emilie Barnes & illustrated by Sandy Lynam Clough, also teacup designer. Permission by Sandy Lynam Clough. Copyright. Harvest House Publishers. All rights reserved.

66—Holly Teacup. Crown. Est. 1801 Staffordshire. England.

67—Christmas Cactus. Teacup is Sadler, Wellington. England.

 —December Flower of the Month. Christmas Rose. Royal Albert. England.

68—Jewel Tea. Superior Hall. By Mary Dunbar Jewel. Homemakers Institute.

69—Golden Teacup, vintage.

 —Tobacco Spit Glaze.

70—Graniteware.

71—Dressed for an Elegant Eve. Teacup and saucer gifted by Jenny. Belonged to my paternal grandma Esther.

72—Made in Occupied Japan.

—New Zealand. Pictures the Pukeko bird of New Zealand. Gifted by Marilyn.

73—Tropical Leaves. Hand-painted. Exclusively made in occupied Japan. G.Z.L. U.S.A.II

74—Got Color? (Lg. photo) Chubu China. Hand-painted Cherry Exclusive. (L to R) American Beauty, Royal Albert/
 Made in Occupied Japan/Embassy Ware, Fondeville, England/Crown of England.

75—Gloves. Teacup gifted by Jenny. Belonged to my paternal grandma Esther. Also pictured is Esther's tea jar.

76—Harlequin Blue. Produced by Homer Laughlin China Co.

77—Baseball.

78—Orchard, Delphine. England.

—American Beauty. Royal Albert. England.

79—Mingling Green. (Top) Alice Jadite. (L) Embassy Ware. Fondeville. England. (Right) Royal Tuscan. England.
 Member of the Wedgwood Group.

80—Highest Bid. Tuscan. Fine bone China. Made i in England.

81—Highest Bid. Tuscan. Fine Bone China. Made in England.

82—Lost and Found. Made in China.

—Nurture. Hand-painted exclusively for Design Pak, Inc.

83—Czechoslovakia. Epiag.

84—Wire Teacup.

85—Russian Teacup.

—USSR Teacup. Gifted by Edith.

86—Tea Chime. Vintage teacups and saucers are "Made Childcraft Italy".

87—Depression Glass. Candy design by Joyce Wilkens.

88—Chocolate Flower by Paula Richards, award winning chocolate designer. The Vintage Truffle Gourmet Tea and
 Coffee Co. (541)992-3632.

89—Chocolate-dipped Teacup by Joyce Wilkens.

90—All Walks of Life (L to R):

—18EB50 Foley. Made in England.

—Nasco. Hand-painted, Japan.

—Hawaiian Wood Rose. Tuscan. Made in England.

—Narcissus. Bell. England.

—Fuchsia Flower and Ballerina.

—Vintage Currier and Ives. Depicts horse-drawn carriage/Steamboat. Royal China Co. 1960's.

—Made in China. Gifted by Barbara and Jim on their return from China.

—Forget-me-not Teacup.

—Chocolate Apothecary. Teacups from the shop.

—Mann Kitten Musical Teacup posed with our beloved cat, Lucy. Permission by Claudia Mann.

—Flower of the Month Series. Made in China.

Joyce Wilkens works in her home in the Pacific Northwest where she and her husband, Keith, have raised their two sons and daughter, Taylor, Fletcher and Emily. Joyce has had formal and informal training in the arts to include music, acting, photography, painting, costume design and Hawaiian hula, as well as several years working as an art/history docent at the Museum of Arts and Culture (MAC) in Spokane, WA. Being an avid fan of nature, recycling and re-purposed things, she uses these in her varied art. Loving the chance to know and appreciate the diversity of people, she pounces on any opportunity to travel, volunteer and share a cup.